Martin Hintz

Charleston · London

The History Press

Published by The History Press
Charleston, SC 29403
www.historypress.net

Copyright © 2010 by Martin Hintz

All rights reserved

Illustrations by Kyle McQueen

First published 2010

Manufactured in the United States

ISBN 978.1.59629.872.9

Library of Congress Cataloging-in-Publication Data
Hintz, Martin.
Forgotten tales of Wisconsin / Martin Hintz.
p. cm.
Includes bibliographical references.
ISBN 978-1-59629-872-9
1. Wisconsin--History--Anecdotes. 2. Wisconsin--Biography--
Anecdotes. I. Title.
F581.6.H56 2010
977.5--dc22
2010012636

Notice: The information in this book is true and complete to the best of our knowledge. It is offered without guarantee on the part of the author or The History Press. The author and The History Press disclaim all liability in connection with the use of this book.

All rights reserved. No part of this book may be reproduced or transmitted in any form whatsoever without prior written permission from the publisher except in the case of brief quotations embodied in critical articles and reviews.

Preface

There are more yarns to tell about Wisconsin than you'd get counting out a bushel of monstrous Rhinelander hodags. These sharp-fanged creatures caused a North Woods panic before the hoax was revealed by a group of Rhinelander pranksters in the late 1890s.

This *Forgotten Tales of Wisconsin* anthology is truly a team project. Subsequently, I'd like to thank all of those old-time newspaper and magazine publishers, editors and reporters who were on the front lines of history when they ran their stories generations ago; plus memoir writers and authors who transcribed the marvelous and the mundane; as well as the museums, the Wisconsin Historical Society and county and city historical organizations with their vast array of archives; genealogy fans, who lovingly research and catalogue the past; and ordinary folks who actually still have the capability to remember things.

Without this deep pool from which to draw facts and features, the tales found in this volume might remain untold and perhaps truly forgotten.

To anyone who loves cheese, badgers, the robin (state bird) and all things Wisconsin, please enjoy reading these anecdotes. Some are sad, some terrifying, some happy, some fun—hey, that's the stuff of Wisconsin history.

Forgotten Tales of Wisconsin

Get the Lead Out

Discovery of lead resulted in the creation of the Territory of Wisconsin, which included lands west of the Mississippi River to the Missouri River. The act creating the Territory of Wisconsin was signed on April 20, 1836, by President Andrew Jackson. Much of the western portion was later transferred to the Iowa Territory, created in 1838.

The town of Petosi along the Mississippi River became the hub of the lead mining industry and was one of the largest communities in the territory. As protection from the weather and robbers, miners regularly dug burrows into the sides of the bluff. A visitor remarked that the holes looked like they had been dug by badgers, hence Wisconsin's nickname became the Badger State, according to a history of the state written by former governor George W. Peck in 1908.

Circus State

Wisconsin has had a storied love affair with the circus. Mud shows—those that traveled overland via wagons—were commonplace in the state before the Civil War. A number of circuses settled in Wisconsin because of the excellent foraging and available fresh water for the animals, the skilled craft workers who made wagons and props and, best of all, the fact that it was a good place to raise kids. Eventually, more than one hundred shows made the state their home.

In 1847, Edmund and Jeremiah Mabie, owners of the U.S. Olympic Circus, moved to Delavan to establish their winter quarters. At the time, it was the largest circus in North America. This was one year before Wisconsin became a state and almost a quarter of a century before the Ringling Brothers made their hometown of Baraboo their base. The Mabies constructed their shops and stables on the shores of Delavan Lake, where today's Lake Lawn Resort is located. Other large circus families in town included the Hollands and the Buckleys.

The town soon attracted more shows, with eventually some twenty-six circuses locating there. Among them were H. Buckley & Co.'s National Circus and the Roman Hippodrome and Universal Fair. Yet one of the most famous was the P.T. Barnum Circus, founded in Delavan in 1871. Only a handful of retired performers and workers still lived in Delavan after the E.G. Holland Railroad

Circus pulled up stakes in 1894. More than 150 clowns, entertainers, trainers and workers are buried at Delavan's Spring Grove and St. Andrew's Cemeteries.

Pink Lemonade

Peter Conklin, an employee of Delavan's Mabie Brothers Circus, ran a refreshment stand for the show in 1857 and is credited with inventing pink lemonade. During one rush by thirsty customers, Conklin grabbed a bucket of water in which an equestrienne had washed out her red

tights. He tossed a couple of lemons into the pink-tinged water and sold the mixture as "strawberry lemonade." Thus a new drink was born.

It's Drafty Here

Wisconsin's residents were not totally in tune with the North's involvement in the Civil War. Many immigrants, fed up with soldiering back in the Old Country, objected to the draft that President Abraham Lincoln instituted in 1862. This was particularly onerous to heavily German communities, since many Germans had left their homeland to escape compulsory military service. Around Janesville, many Irish simply did not register with the sheriff, being afflicted by the so-called "blue flu" (referring to the color of the Union uniforms). Throughout the state, numerous able-bodied men went off to Canada. Unable to meet the federal quota, Governor Edward Salomon appointed a draft commission in charge of conscripting men for the army.

This did not go over well. On November 10, 1862, more than one thousand rioters attacked the draft office in Port Washington and smashed the homes of Union supporters. That disturbance was eventually quelled by troops sent by Salomon, but unrest continued throughout the state. In Milwaukee, during the same week as the Port Washington riot, a mob shut down the draft proceedings, and in West

Bend, the draft commissioner was badly beaten and chased out of town

To forestall any further disturbances in Milwaukee, the governor placed Colonel John C. Starkweather in charge of keeping the peace there. His reports, on file at the State Historical Library, indicated that as a result, "absolute quiet prevailed throughout the city."

However, many Wisconsinites still objected to the war, particularly as the conflict ground on and on and deaths mounted. Among the protesters was Marcus (Brick) Pomeroy, editor of the *La Crosse Democrat* newspaper, whose searing editorials blasted the Lincoln administration during the presidential campaign of 1864. Early on, Pomeroy had been an ardent patriot; he had even tried to raise his own company of soldiers to be called "the Wisconsin Tigers."

Seeing no end to the war and feeling that the Northern officers were more concerned with getting promoted than fighting, Pomeroy labeled the president "the Widow-Maker of the Nineteenth Century." In one column, Pomeroy wrote:

> *The man who votes for Lincoln now is a traitor and a murderer. He who pretending to war for, wars against the constitution of our country is a traitor, and Lincoln is one of these men...And if he is elected to misgovern for another four years, we trust some bold hand will pierce his heart with dagger point for the public good.*

Yet when Lincoln was assassinated, Pomeroy called for the killer's blood, saying that the culprit should be "hung in chains to starve to death." But that wasn't enough for his many enemies, one of whom said that Pomeroy "out-jeffed Jeff Davis [president of the Confederacy] in treasonable utterances and out-deviled the Devil in deviltry."

Yet thousands did rally around the Union flag, even in ethnic neighborhoods. The Seventeenth Wisconsin was known as the Irish Regiment, and the Fifteenth Wisconsin Infantry, the "Scandinavians," had so many Ole Olesons in its ranks that they were assigned numbers. Germans, many from Milwaukee, joined the Ninth, Eighteenth, Twenty-sixth and Twenty-seventh Wisconsin Infantry Regiments. Even Native Americans signed up, with Chippewas, Oneidas, Stockbridges, Menominees and Ho-Chunks being incorporated into various units.

An estimated 129 African Americans from Milwaukee, La Crosse and Prairie du Chien also enlisted, including several slaves. They formed Company F of the Twenty-ninth U.S. Colored Troops, a regiment that suffered heavy losses in the siege of Petersburg. The Wisconsin men arrived on July 22, 1864, and 11 died within the first week outside the city's defensive ramparts. More were killed in the final assault on July 30.

Wisconsin's First Civil Rights Act

As early as December 1889, legislation was discussed to protect the civil rights of the state's black population. Yet it wasn't until January 1891 that the legislature finally convened and a bill was introduced. It was comprehensive, declaring "inns, restaurants, saloons, barber shops, eating houses, public conveyances on land and water, theaters and all other places of public accommodation or amusement" as open to all persons.

The bill even specified that no one would be required to pay more than the regular rate for any of these services. Anyone violating the law would be socked with a misdemeanor and fined no less than $25 and no more than $500; a violator could also be jailed for up to one year for each offense.

The legislation was introduced by Milwaukee assemblyman Orren T. Williams, who represented the city's Fourth Ward. He was a minority member of the judiciary committee, which held hearings on the motion. Among those testifying was William Green, a black student attending the University of Wisconsin–Madison law school. Green, one of William's constituents, would become the university's first black graduate.

However, the committee emasculated the bill by cutting out the list of public places. On March 11, the lower house of the state legislature debated the bill, mostly along partisan lines. The *Madison Democrat* reported that "Republicans seek

to make capital out of the Civil Rights Bill, but their game is blocked and they themselves placed on record."

Williams cited the civil rights acts just passed in Michigan and Minnesota, but opponents said that the original bill was too broad and would place "extreme expectations" on businessmen. Others argued that there was no need for such a law because "the negro in Wisconsin had…all the rights he can reasonably expect." Still more were outright racists, such as Democratic assemblyman John Winans, who argued, "Where is the man on this floor who will say the colored man is equal of the white man? God did not create them equal." He also claimed that legislation making them equal would "do them harm."

The next day, the *Wisconsin State Journal* scoffed at Winans's assertions, saying that his comment "had a great deal of moss on it." But the bill failed when the senate refused to take any action.

Under Democratic control of the 1893 legislature, no civil rights legislation was brought up. But the 1894 elections returned a Republican majority to both houses. On February 12, Lincoln's birthday, Milwaukee senator William H. Austin reintroduced Williams's original bill. At the same time, assemblyman Reinhardt Labunde, a Milwaukee liquor supplier doing double duty as a politician, did the same in the lower house. Unlike the earlier bill, this legislation passed quickly through the committee and the legislature.

On April 20, 1895, Governor W.H. Upham signed Wisconsin's first civil rights act, outlawing discrimination at a long list of public places under penalty of a fine from $5 to $100 or six months' jail time.

Love Affair With the Car

Since 1900, more than eighty different makes of cars and trucks have been manufactured in Wisconsin, according to the Wisconsin Historical Society. Yet the love affair with the automobile started even earlier. Racine inventor Reverend Dr. J.W. Carhart designed and built the United States' first steam-powered, self-propelled vehicle way back in 1873.

In 1875, a $10,000 purse was offered by the Wisconsin legislature to the winner of a race between Green Bay and Madison, with the politicians hoping to find a "cheap and practical substitute for the use of horses and other animals on the highway and farm." According to the rules, the winning vehicle had to complete a route of at least two hundred miles, "propelled by its own internal power, at the average rate of at least five miles per hour, working time." Two companies managed to take up the offer and began racing in July 1878. The entry sponsored by a group of investors from Oshkosh completed the trip in thirty-three hours. The other car broke down early and was hauled back in disgrace to Green Bay.

Wisconsin's automobile age began in earnest during the late 1890s, with the *Milwaukee Sentinel* noticing that at that year's state fair, "automobiles dashed hither and thither." In 1901, autos were so prevalent in Milwaukee that the city council passed an ordinance limiting their speed to four miles per hour. When popular politician Bob LaFollette was running for reelection as governor in 1902, he used a car to tour the state and attracted attention wherever he went.

By 1907, nondriving/horse-fancying members of the legislature had proposed that speed limits of only eight miles per hour on city roads and twelve miles per hour on rural roads be allowed. Car enthusiasts thought this speed rule was much too restrictive and actively argued for more leniency. As part of this effort, James Drought, director of the newly organized Milwaukee Auto Club, gave rides

around the state capitol building in Madison, demonstrating that cars could safely negotiate city streets by going faster than the slow speeds originally suggested. As a result, that speed limit law failed to pass. However, in 1909, Governor James O. Davidson vetoed a bill that elevated the legal city speed to eighteen miles an hour, stating that the rate was "highly improper and dangerous."

None of this deterred entrepreneurs, who were busy turning out models, each hoping that his vehicle would capture the public's fancy and snare the contents of its pocketbooks.

In 1902, bicycle manufacturer Thomas Jeffrey of Kenosha had switched gears to make the state's first mass-assembly automobile, the Rambler. This was about one year before Henry Ford's introduction of his Model A.

In his first year, Jeffrey peddled 1,500 of his cars, making it sixth in rank of all autos sold in the United States at the time. Jeffrey died in 1910; his son, Charles, took over the firm. Sales for the family's Thomas B. Jeffrey Company peaked in 1914 with 13,513 vehicles sold. Charles W. Nash, former General Motors president, acquired the Jeffrey firm in 1916, forming the Nash Motor Company, which became the platform for launching the American Motors Company.

Kenosha, where the Nash brand was manufactured, also played a major role in the history of labor rights. Workers at the Nash auto plant unionized in 1933, two years before the United Auto Workers (UAW) was organized. The always-feisty Charlie Nash asserted that he would toss the keys to his plant doors into Lake Michigan before he would ever

bargain with a union. But under pressure from the federal government, Nash relented. In 1935, his company's union joined forces with the UAW.

George Kissel, a farm equipment manufacturer in Hartford, made the jump to autos in 1906, with models such as the Gold Bug speedster and White Eagle sportster becoming popular in the 1920s. The firm lasted until 1937; its cars were famous for their quality manufacturing, low center of gravity and excellent braking systems.

After a time, some of Kissel's custom-built bodies were manufactured by the C.T. Silver Motor Company, owned by Conover Thomas Silver, an auto dealer and parts manufacturer in New York City. The link between Kissel and Silver was appropriate, especially with the New York firm's connections to high-end clients, who appreciated the Wisconsin company's exceptional workmanship.

The September 25, 1910 issue of the *New York Times* had written about Silver's upscale new Manhattan showroom, one that featured several vehicle lines:

> *What promises to be one of the most interesting and prominent openings of an automobile salesroom in Manhattan will occur to-morrow, when the Overland Sales Company will throw open its quarters at 1599 and 1601 Broadway, New York, for public inspection. The show room is magnificently equipped with a complete line of cars, consisting of seven different 1911 Overland models. The entire two-*

story-and-basement building will be used exclusively for the sale and repair of Overlands: C.T. Silver will act as manager of the salesroom.

The Wisconsin company's speedster, tourster and seven-passenger touring car were advertised as "Kissel Kar Silver Specials" at the New York Auto Show in January 1918. The company's new four-passenger, two-door vehicle came with sliding front seats—a brilliant engineering idea that attracted customers, according to historian Mark Theobald. Kissel made 21,412 autos between 1907 and 1931 that ranged in price from $1,350 for low-end models up to $3,000 for its six-cylinder lines.

In Racine, the Mitchell-Lewis Company began building touring cars to complement its manufacturing of traditional farm wagons. By 1911, the Mitchell-Lewis Motor Company had become the city's largest employer, with two thousand workers in its plants. In 1925, the Nash Motor Company purchased this successful company.

Auto historians credit Wisconsin automakers with developing numerous technical innovations, including the steering wheel, the seat belt and the muscle car. Among these creative Badger State engineers were William Besserdich and Otto Zachow of Clintonville, who invented the four-wheel drive in 1906. Their Four Wheel Drive Company (FWD) helped make their hometown a hub of heavy truck production. During World War I, Besserdich and Zachow produced 14,473 trucks for the U.S. government.

The trucks were built to a standard four-foot, eight-and-a-half-inch width so they could be used on standard-gauge railroad tracks when the wheels were changed.

On June 14, 1911, Governor Francis E. McGovern signed a bill providing financial aid for highway construction. Wisconsin joined the thirty-eight other states that already provided such assistance.

THE PEOPLE'S POLITICIAN

"Socialism" was not a dirty word in nineteenth- and twentieth-century Wisconsin; it came to the state in the 1840s along with a wave of politically progressive German émigrés. This popular movement advocated such bizarre notions as the eight-hour workday, restrictions on child labor, community ownership of public transportation and an end to wars. Wisconsin's so-called sewer socialists, organized as the Social-Democratic Party, pushed for honest, efficient government, good roads and streetcars that ran on time. They achieved many of their goals through enlightened legislation.

Milwaukee newspaper publisher Victor Berger became the symbol of Wisconsin socialism. In 1910, he became the first socialist elected to Congress. In the same year, socialist Emil Seidel was elected Milwaukee mayor, the first in a string of such political leaders that extended into the 1960s.

Berger organized the Social-Democrats into a highly successful political organization that drew on Milwaukee's

large German population and active labor movement. He outlined his views in a compilation of his writings entitled *Broadsides*, published by the party in 1912. Berger always proudly emphasized that his movement was "revolutionary," not "in the vulgar meaning of the word, which is entirely wrong, but in the sense illustrated by history, the only logical sense. For it is foolish to expect any result from riots and dynamite, from murderous attacks and conspiracies, in a country where we have the ballot."

Yet there were many who favored more direct, sometimes violent, action to achieve their political goals. A battle erupted at the national convention of the Socialist Party in 1912 over language to be inserted into the party constitution that called for the expulsion of "any member of the party who opposes political action or advocates crime, sabotage, or other methods of violence as a weapon of the working class to aid in its emancipation." Berger was more moderate than many other delegates, readily making his positions known in speeches at the convention:

> *Comrades, the trouble with our party is that we have men in our councils who claim to be in favor of political action when they are not. We have a number of men who use our political organization—our Socialist Party—as a cloak for what they call direct action, for IWW-ism, sabotage and syndicalism. It is anarchism by a new name.*
>
> *Comrades, I have gone through a number of splits in this party. It was not always a fight against anarchism*

in the past. In the past we often had to fight utopianism and fanaticism. Now it is anarchism again that is eating away at the vitals of our party.

If there is to be a parting of the ways, if there is to be a split—and it seems that you will have it, and must have it—then, I am ready to split right here. I am ready to go back to Milwaukee and appeal to the Socialists all over the country to cut this cancer out of our organization.

Although he lost congressional elections in 1912 and 1914, he ran again and won in 1918. However, the House of Representatives refused to seat him, convicting him in 1919 of violating the Espionage Act for the antimilitarist views in his newspaper, the *Milwaukee Leader*. The trial was presided over by Judge Kenesaw Landis, who later became the first commissioner of Major League Baseball.

Since Congress wouldn't seat Berger, Wisconsin held a special election and once more voted him into office. Again, the House refused to allow him to take his seat, and it remained vacant until 1921, when Republican William H. Stafford took his seat. In that same year, Berger's espionage conviction was overturned upon appeal to the United States Supreme Court

All this time, Berger never gave up his political aspirations. He ran again in 1922, this time defeating Stafford. He was finally allowed to take up his post, and he then served three successive terms. While in office, Berger fought for elderly pensions, unemployment insurance and public housing. He

lost the 1928 election to his old foe, Stafford, returning to Milwaukee to resume his newspaper career.

Unfortunately, Berger was struck by a streetcar on July 16, 1929, and died of his injuries on August 7. His body lay in state in Milwaukee's expansive city hall rotunda, with more than seventy-five thousand persons filing past his coffin to pay their respects.

SHAM BATTLE

Thousands of spectators watched a re-creation of a World War I battle staged by eight Wisconsin National Guard units at the Janesville fairgrounds on September 18, 1921. Many of the participants were World War I veterans, who showcased their marching, riding and shooting skills.

The *Beloit Daily News* reported:

> *The sham battle was not a fireworks display. Rockets and aerial flares were used as they are in night attacks to light the enemy's advance from time to time. Officers arranging it endeavored to give as accurate an idea of one hour of a certain phase of the Chateau Thierry offensive as possible without the use of very high explosives which would have broken windows in the vicinity.*

The display started with a skirmish line, followed by an artillery barrage and an infantry attack by the Wisconsin

soldiers. "The machine gun fire and shrapnel of the defense drove them back a short distance. The tanks were then brought into action and a bayonet wave followed them in a charge which took the defensive positions," the newspaper indicated.

The *Times* added that Governor John Blaine and Colonel James Quill of the 105th Cavalry, watching from the grandstand, "expressed themselves as highly pleased with the maneuvers."

First Vote

Milwaukee's first black resident was Joe Oliver, the cook and man-about-town for the city's founder, Solomon Juneau. Oliver is recorded as voting in the city's first election in 1835. Yet it took the hard work of former slave Ezekiel Gillespie many years later to guarantee that right. Gillespie had been turned away from a polling place in Milwaukee's Seventh Ward in 1865, but he sued the state to affirm the right of Wisconsin's black citizens to suffrage. He based his argument on the fact that the state voters had approved an 1849 referendum allowing voting by African American men. In 1866, the Wisconsin State Supreme Court eventually agreed with Gillespie after a bitter legal fight in the lower courts. It wasn't until 1870, with the ratification of the Fifteenth Amendment, that black men could vote nationally.

Off We Go in Our Flying Machine

The first recorded airplane flight in Wisconsin took place on November 4, 1909, with pilot Arthur P. Warner taking off from a farm field near Beloit. He soared fifty feet off the ground before landing a quarter of a mile down the road. Warner might have gotten farther, but he didn't know how to turn the plane. He had purchased a "flying machine" that looked like a tricycle with wings from pioneer aviator

Glenn Curtiss. This transaction was the first-ever sale of an airplane to a private individual. The device, which Warner had to assemble himself, had a twenty-seven-foot wingspan and a twenty-five-horsepower engine and was made of wire, bamboo and spruce slats.

Warner, thirty-nine at the time of his historic launch, was a self-taught engineer who had invented the first automobile speedometer along with his brother, Charles. Warner also invented the electric brake and a power clutch for automobiles, as well as a vacation trailer for motorists. In 1912, he sold his little airplane to a stunt pilot, and it flew off into history.

The famous Wright brothers of aviation fame put on a flying demonstration at the Wisconsin State Fair the year after Warner's inaugural flight. Flying a Wright Model B on September 13, 1910, exhibition pilot Arch Hoxsey made it to an altitude of seven hundred feet and cruised overhead for seventeen minutes in what was the first airplane flight in Milwaukee County. The newspapers recorded that "the crowd below maintained a hushed quiet throughout."

He wasn't as lucky the next day, crashing into the grandstand and injuring nine men and women. According to reporters:

> *Soon after he was airborne, a freak gust of wind tipped his wing, banking the plane and veering it toward the stands…the machine glided over the picket fence in front of the stands and crashed head on into*

the first row of seats. The spectators scrambled as fast as they could, but a "score of persons" were caught under the machine.

The accident subsequently resulted in two historical landmarks. It was the first recorded airplane crash in Wisconsin and resulted in the nation's first aviation lawsuit, one in which the Wright brothers paid Emily Morrison $4,000 because of her injuries suffered as a result of that ill-fated flight.

Ever "On Wisconsin!"

On November 13, 1909, the University of Wisconsin marching band played the school's fight song—"On Wisconsin!"—for the first time. Unfortunately, despite the rousing tune, the Badgers were whumped, thirty-four to six, by the Cheese State's gridiron nemesis, the University of Minnesota Gophers.

Actually, the song had originally been written by William T. Purdy for the Minnesota school, in a competition offering a $100 purse. But Purdy's friend Carl Beck, who attended UW-Madison from 1908 to 1909, convinced him to give it to Wisconsin.

Favorite Animal

William D. Hoard (1836–1918) is considered the father of the Wisconsin dairy industry. He played a major role in developing the University of Wisconsin–Madison's School of Agriculture and published *Hoard's Dairyman*, an industry magazine still circulating.

> *I have given years of study to the dairy cow, and I believe that I know a good deal about her, but more and more I am becoming convinced that the darkest place on earth is the inside of a cow. Chemists have their laboratories for research and investigation; mechanics have their mechanisms to aid them in the search for truth, but no human agency has been*

devised to enable us to discover how the dairy cow transforms the hay and grain that she eats into milk. I never look at a cow but that I think of her with humility and a feeling of awe and inspiration.

Stamp of Approval

It was barely a generation before the barns, stables, training rings and other circus landmarks had disappeared from Delavan, where many early circuses had their winter quarters. To remember those years, the U.S. Postal Service chose the south central Wisconsin city to issue the five-cent American Circus Commemorative Postage Stamp on May 2, 1966. Today, a statue of a rearing circus elephant stands over the downtown square.

Foodies Fight the Good Fight

Wisconsin's citizens cut back on meat, bread and other staples as the county became swept up in World War I. Governor Emanuel L. Philipp appointed Madison's Magnus Swenson to oversee the State Council for Defense to help mobilize the state and prevent profiteering.

On Friday, September 14, 1917, Swenson issued the following proclamation:

Pursuant to the authority vested in him by the President of the United States, Herbert Hoover, National Food Administrator, has urged as a patriotic duty one meatless day and one wheatless day in each week as a means of conserving the food supply.

Owing to the very great shortage of wheat and meat, and the urgent necessity of conserving the present food supply and of creating a reserve supply for future needs, the people of this Nation have been asked to make personal sacrifices. It is through their cooperation alone that the food administration can be successfully carried out.

Therefore, acting under the direction of Food Administrator Herbert Hoover, I, Magnus Swenson, Food Administrator for Wisconsin, hereby call upon and urgently request the citizens of this state to set aside Tuesday, September 18, 1917, and each Tuesday thereafter during the period of the war as a meatless day. I ask that all hotels, restaurants and other eating places serve meatless nights upon that day and that this practice be followed in the homes of all patriotic citizens.

In order, further, that Wisconsin may do its share in the conservation of food, I ask that Wednesday, September 19, 1917, and each Wednesday thereafter during the period of the war be set aside as a wheatless day. I ask the people of Wisconsin to abstain from the use of bread and pastries made from wheat upon that

day to the end that the wheat supply of the United States may be increased for the time when greater calls will be made upon it.

There were amusing incidents around the meatless and wheatless days, according to historian R.B. Pixley in his 1919 book *Wisconsin in the World War*.

"Give me some shredded wheat," said the patron of the restaurant, while visiting from another state.

"No wheat today," replied the waitress.

"What's the matter with this state," asked the man. "I asked for meat yesterday in Milwaukee and did not get it."

"That was meatless Tuesday," was the reply, "and this is wheatless Wednesday. We've got to win the war."

"By George, that's so," replied the man. "Give me a cheese sandwich, and, say, put it on rye bread."

Students at the University of Wisconsin-Madison jumped on the patriotic bandwagon, signing a special pledge card to cut back on certain foods.

The card stated:

I promise as a voluntary member of the food administration to keep the meatless Tuesday and wheatless Wednesday pledge, and in addition I promise:

1. To have at least 7 wheatless meals a week.
2. To have at least 7 meatless meals a week.

3. *To use at least one less pat of butter a day.*
4. *To omit between meals ice cream, candy and other luxuries.*
5. *To cut the use of candy at least one-third.*

Bad Luck Town

On a frightening May 22, 1918, a tornado cut a swath three hundred feet wide through Lone Rock and then smashed its way along another eighty destructive miles through Wisconsin's soul. Local papers reported the results of the storm's fury:

> *P.C. Pitkin, aged 40, lawyer, graduate of the University of Wisconsin and editor of* The Tri-County Review, *head crushed. Miss Clara Hatrey, aged 13, killed outright. Donald Hatrey, aged 7, killed outright. Five more persons died and about one hundred were injured in outlying communities as the deadly storm thundered along from the southwest into the far northeast.*

Lone Rock had not been immune from other catastrophes. Three large downtown retail buildings were destroyed by the village's first major fire in 1892, started by a charge blasted by a burglar struggling to open a heavy safe in the Fuller and Foster dry goods store. Lone Rock's other major fires occurred when the grade school was destroyed in 1864

and five buildings in the Union Block burned to the ground in 1942.

In 1988, the Franklin Masonic Lodge and an adjacent building were destroyed in a blaze of suspicious origin. Again on the crime log, bank robbers hit the Farmers Bank in 1934, escaping with $2,700 in cash. In 1975, another gang hit the State Bank of Lone Rock in a daring raid in which it got away with $3,863.

Whole Lot o' Shakin' Goin' On

Wisconsin has generally been free of earthquakes, but several have shaken up the state over the years. The 1909 Wabash River quake rattled state residents living along the Wisconsin-Illinois border. Two other quakes were recorded in 1912, with shocks also being noted in 1919 and 1925, the first centered in Missouri and the second in Canada. As a result of the wide area affected, Wisconsin escaped with relatively little damage. Windows shook and trees swayed in temblors felt in 1937 and 1939, according to the United States Geological Society (USGS).

The largest recorded quake occurred at 4:25 a.m. on May 6, 1947, affecting three thousand square miles but centering on an area just south of Milwaukee. The shock was felt in a ninety-nine-mile-wide strip from Sheboygan to the Wisconsin-Illinois border and extended from the lakeshore to Waukesha, twenty-four kilometers inland, the

USGS said. Newspapers reported broken crockery and windows, with many buildings emptied of workers, who feared that an explosion had occurred nearby. The quake was strong enough to break a seismograph at Marquette University in Milwaukee.

The strongest earthquake in the central United States in seventy-four years occurred on November 9, 1968, in south central Illinois. Shaking and some damage resulting from this quake were recorded in Jefferson, Kenosha, Baraboo, La Crosse, Milwaukee, Port Washington, Portage, Prairie du Chien and Sheboygan. Another shake, rattle and roll occurred on September 14, 1974, with newspapers recording cracked plastering and leaking water pipes in several Wisconsin cities. Those affected included Kewaskum, Milton, Nashotah, Zenda and Browntown.

Tune In, Stay On

A plaque on the wall of the Vilas Communication Hall at the University of Wisconsin–Madison campus makes note of the pioneer research and experimentation in "wireless" that evolved into the successful transmissions of voice and music in 1917. This led to the start of scheduled broadcasting in 1919. Experimental station 9XM initially sent telegraphic signals from the university's Science Hall until 1917, when it was moved to Sterling Hall. In that

year, Professor Earle M. Terry and his students built and operated a "wireless telephone" transmitter.

In 1918, during World War I, when other stations were ordered silenced, 9XM received special authorization to continue its telephonic exchange with U.S. Navy stations on the Great Lakes. After the war, programs were redirected to the public. The WHA letters replaced the 9XM call on January 13, 1922. Subsequently, the University of Wisconsin station, under the calls of 9XM and WHA, has been in existence longer than any other broadcast outlet in the country.

No Place Like Home

Life in a typical northern Wisconsin logging camp was not pretentious, as described by Louie Blanchard in his memoirs entitled *Lumberjack Frontier*. Blanchard logged along the Upper Chippewa River during the late 1890s, starting in the camps at age fourteen. He eventually retired in 1912 and took up farming cutover forestland. As a young man, he was known as a "river driver" and for his skill in breaking up jams when the logs were being floated downstream to mills.

Here's how Blanchard described a typical logger hut in which dozens of men lived throughout the winter. (Even after a full day in the woods, they stayed up late in the night sharpening their saws.)

Along the sides there was a lot of racks to hang sock [sic] and clothes on to dry at night. Everybody's got wet from the snow every day and we needed a lot of racks for drying. When the socks began to send off steam at night, you sure knowed you was in a logging camp. When you mix the smell of wet socks with the

smell of baked beans and chewing tobacco, you have a smell that a lumberjack never forgets even if he lived as long as Methuselah.

Football Legends

Fame is fleeting in the sports world. Sometimes a name lives on, yet few fans recall the particulars of a person being immortalized. Such is the case with John Heisman.

Born on October 25, 1869, Heisman was a noted football player and college football coach at Oberlin, Auburn and Georgia Tech in the late 1800s and early 1900s. He coached the Georgia Tech Engineers when they trounced the Cumberland College Bulldogs, 222–0, in a game played in Atlanta in 1916. This game is considered the most one-sided college football game ever played.

After his innovative three-decades-long college career, Heisman became the athletics director at what was then the Downtown Athletic Club in Manhattan. In 1935, the club started giving out a trophy for the best football player east of the Mississippi River.

Heisman died on October 3, 1936, in New York City. Three days later, he was taken by train to his wife's hometown of Rhinelander, where he was buried in Grave D, Lot 11, Block 3 of the city-owned Forest Home Cemetery.

Two months after his death, the athletic club trophy was renamed in his honor. The Heisman Memorial Trophy is now given to the college player considered the season's best, with media representatives voting for the honoree. It's not known if any trophy winner has ever visited Heisman's grave in northern Wisconsin.

One of the most famous Heisman Trophies, won by University of Wisconsin–Madison player Alan Ameche, is displayed at Camp Randall Stadium in Madison. The player donated his prize to the university in 1984. Ameche, who was born in Kenosha on March 1, 1933, was nicknamed "the Horse" for his speed. After graduating from college in 1955, Ameche played six years for the Baltimore Colts and was elected to the NFL's Pro Bowl in each of his first four seasons. He is most known for his winning touchdown in the 1958 NFL championship game over the New York Giants, called "the greatest game ever played."

In addition to capturing the Heisman, Ameche was inducted into the College Football Hall of Fame in 1975, named to the Wisconsin State Athletic Hall of Fame and earned numerous other awards. A successful restaurant owner following his playing days, Ameche died a multimillionaire on August 8, 1988. His jersey, number thirty-five, was retired in a ceremony at the university in 2000.

Big Blow

Newspapers across the country reported on the "terrible whirlwind" that heavily damaged the village of Pensaukee at 6:45 p.m. on Saturday, July 8, 1877, killing eight and injuring dozens of persons. The first dispatches reported that only three houses were left standing and that the Gardner House was demolished. At the time, the hotel was the largest brick structure in northern Wisconsin.

"The storm tore up large trees as though they had been weeds, and whirled them in the air like feathers," according to the next morning's reporting.

Pensaukee, twenty-five miles north of Green Bay, was a prosperous lumbering and railroad community that suffered more than $350,000 in damages when twenty-eight homes, the schoolhouse, a sawmill, a shingle mill and other factories were demolished. The depot was blown across the Chicago & Northwestern Railroad tracks, blocking trains for hours.

A telegram to the newspaper reported on the grim list of casualties:

> *L. Zanto, H. Baumgardner, Jr., Albert Blackbird, Mrs. E.R. Chesley, an infent* [sic] *of Farley, and an infant of L. Zanto—in all, six. The last named has not been found. The wounded are Albert Gosky, shoulder and face; Herman Baumgardner, Sr., breast, leg and heel; Wm. Baptiste, head; Martha Morrison, badly bruised; Mrs. L. Zanto, leg broken*

and cut; Mrs. F. Farley, generally bruised; boy and girl of E.R. Chesley, badly hurt in face; Mrs. Chapman, generally bruised; John Dinse, face and breast. All the wounded are doing well, and it is thought will recover. The tornado was not over one thousand feet in width, and lasted but two minutes. Its velocity and power were terrific.

After cutting through Pensaukee, the storm raged along to Contlardville, "taking in a streak of about 80 rods wide, and destroying everything in its course. Seventeen houses and barns were damaged in Coullardville [Contlardville], and the crops are badly injured."

Bad, Bad Boys: Barstow and Bashford

During the William A. Barstow Democratic gubernatorial administration between 1854 and 1855, several scandals were unearthed. The infractions concerned land speculating by state officials, compounded by charges of bribery, "malfeasance in office" and other misdeeds "being freely circulated." An investigation revealed a shortage in the accounts of the state treasurer of nearly $40,000, which was never made good. A Madison printer seeking to nail down the state's printing contract wrote to a partner that "we must get a good bid, even if we have to buy up Barstow and the balance." The letter was made public, giving

Barstow's opposition plenty of campaign ammunition, although the governor was not personally implicated.

Among his accomplishments, however, Barstow opposed prohibition of alcohol sales and vetoed such a ban passed by the legislature. He also worked hard against the rise of the Know-Nothings, who wanted to deny citizenship to foreign-born residents of Wisconsin.

In 1856, the election was so close between Barstow and his Republican foe, Coles Bashford, that charges of vote rigging surfaced. Each man claimed the governor's seat and hosted his own swearing-in ceremonies on January 7, 1856. Each side brought its own militia unit to keep the other side at bay. However, by that May, the State Supreme Court had found evidence of voter fraud against Barstow, forcing him to step down. Until Bashford took office, Lieutenant Governor Arthur MacArthur Sr. was in charge.

On the day he came to the governor's office, MacArthur asked, "Will force be used?" when he saw a contingent of muscular Bashford aides. "I presume no force will be necessary," Bashford replied, "but in case any be needed, there will be no hesitation whatever, with the sheriff's help, in applying it." MacArthur then left the capitol "to the sound of jeers and hoots from an assembled crowd," according to the next day's newspapers.

Bashford's administration was no better than that of his predecessor, with the exposure of fraud committed during the parceling out of railroad lands and bribes being paid.

Bashford was able to remain in office and finish his term but left Wisconsin in 1863 to live in the Arizona Territory, where he died in 1878.

The one bright light in this affair was MacArthur, who served as governor for the four days between the Barstow-Bashford administrations. He was later appointed an associate justice in the Supreme Court of the District of Columbia. MacArthur had two sons, Frank and famed General Arthur MacArthur Jr. The latter, as a first lieutenant in the Twenty-fourth Regiment of Wisconsin Volunteers in the Civil War, earned a Medal of Honor and was made a colonel at age nineteen. Arthur Jr. was

himself the father of famed World War II and Korea commander General Douglas MacArthur and Arthur MacArthur III, who earned a Naval Cross for his exploits in World War I.

Circus Town

Delavan was not the only circus town in Wisconsin. Baraboo, along the slowly moving Wisconsin River in the center of the state, was the longtime winter quarters of the Ringling Brothers. The "Rungeling" family moved to Baraboo from McGregor, Iowa, where the Ringling boys grew up, and their father, August, was a harness maker. The eldest brother, Albert (Al), was afflicted with the circus bug early on, even though he worked full time for a carriage manufacturer. His skills as a juggler and acrobat eventually led him to begin performing in 1879.

In the early 1880s, Al was joined by his other brothers—Charles August (Gus), Otto, Alfred Theodore (Alf T.), Charles Edward (Charley), John and Henry—in starting a small wagon show called the Yankee Robinson and Ringling Brothers Circus. It quickly became a success, using the brothers' collective talents as musicians, actors and acrobats, as well as presenting themselves as running a "highly moral" circus. By 1890, the Ringlings had moved from being a "mud show," slogging overland in wagons, to a much larger railroad operation. They

called themselves the Ringling Brothers United Monster Railroad Shows, Menagerie and Museum.

The Ringlings wintered in Baraboo for thirty-four years, Each year, just before starting on their seasonal route, even as they expanded, the Ringlings gave a free performance to the townsfolk of Baraboo, thanking them for their support throughout the year. The brothers had purchased their largest rival, the Barnum & Bailey Circus, in 1907. The two huge shows merged in 1918, and the Ringlings moved their winter base from Baraboo to Bridgeport, Connecticut.

While the Ringling show was growing, it was regularly caught up in a fierce war of words with its competitors. One famous barrage occurred in Milwaukee in 1892, when Barnum & Bailey issued what were called "rat sheets," printed in both English and German.

The fliers reproduced newspaper stories relating how Ringling billposters had been arrested for defacing, tearing down or covering posters of other shows. The Barnum bunch declared:

> *Neither is it expected that an auction-made, secondhand concern, whose "sumptuous wardrobe" was selected from the cast-off discarded stock of really progressive shows, can in any way compare with "Caesar's Triumphal Entry into Rome" as advertised by this little show. Shades of Baraboo, go hunt your tub!*

The Ringlings fired back with a proclamation:

> *Having been unjustifiably and maliciously assailed by a certain rival show, in calling attention to the falsity of these statements, we will indulge in no mudslinging, no vituperation and no ill-tempered and unsavory language such as our maligners have seen fit to resurrect from the slums of Ellingsgate and which can only serve as a boomerang upon the heads of those who indulge in it.*

Man of All Trades

Bill Becker was village marshal of Westfield, a community in central Wisconsin, from 1948 to 1965. The town's *Centennial Memories* book presented many fun interviews and stories from the "old days." Becker's job was described as including "everything from helping little children cross the street to collecting garbage, fixing the streets, plowing snow, acting as the town jailer, putting up Christmas decorations and various other tasks."

A newspaper article in 1954 indicated that

> *on Tuesdays, Becker gets up at 3 a.m., works right through to 4 p.m. collecting garbage over the entire village. The average is 14 loads he must take to the village dump. He halts only to eat and to direct traffic when children are coming and going to school.*

> *When an engineering firm came to town this week to make a preliminary survey for the laying of sewers, it was Becker who assisted, holding the level rod for the surveyor.*

In the Westfield centennial volume, Judy Tymusz, Becker's granddaughter, recalled that if someone was locked up in jail, "Grandpa had to stay with him, even if it was overnight, because there was no jail staff."

Relating her favorite Christmas memory about Grandpa Becker, Tymusz said that after attending church services, she and her brother, Randy,

> *would go for a ride with Grandpa while Santa came. We always went to the village hall and visited "the boys." Grandpa would take them a stick of sausage, cheese and usually a pint of blackberry brandy. The cell was not locked and they had a warm place to spend Christmas Eve together.*

According to Tymusz, "the 'boys" were the guys known as the town drunks. "We would tell them Merry Christmas and be on our way home," she recalled.

> *Grandpa was also responsible for switching on and off the strings of Christmas lights that went across Main Street and 2nd Street. I remember following him along the way, tavern owners would come out*

and give him miniature bottles of Mogen David wine in appreciation for his duties; they would give me a candy bar.

In Becker's time, there was no police car, so he had to use his family vehicle, a 1948 coupe.

All Wet

Frederick Marryat was a former English naval officer who traveled between Green Bay to Fort Winnebago in 1837 and described his travels through the wilderness. Marryat had resigned his commission in 1830 to pursue a career as a novelist and magazine publisher. However, during his wanderings around Wisconsin, a rebellion broke out in Lower Canada, and Marryat rejoined the military. He served with the British forces in suppressing the revolt known as the Patriot War. Since there were numerous cross-border raids carried out by Americans friendly to the revolutionaries, one of Marryat's duties was to keep tabs on Wisconsin's allegiances.

A friend of writer Charles Dickens, many of Marryat's books focused on adventures in the Royal Navy based on his experiences at sea. His works were the models for many other authors, such as Joseph Conrad, Ernest Hemingway, Patrick O'Brian and C.S. Forester.

His diaries detail his experiences in the Wisconsin woods:

> *The last night we bivouacked out was the only unfortunate one. We had been all comfortably settled for the night, and fast asleep, when a sudden storm came on, accompanied with such torrents of rain as would have washed us out of our tents, if they had not been already blown down by the violence of the gale. Had we had warning, we should have provided against it; as it was, we made up huge fires, which defied the rain; and thus we remained till daylight, the rain pouring on us, while the heat of the fire drying us almost as fast as we got wet, each man threw up a column of steam from his still saturating and still heated garments. Every night we encamped where there was a run of water and plenty of dead timber for our fires; and thus did we go on, emptying our wagons daily of the bread and pork, and filling up the vacancies left by the removal of the empty casks with the sick and lame, until at last we arrived at Fort Winnebago.*

Sells-Sterling Showcase

Sheboygan was also home to several circuses. The city, on the shore of Lake Michigan, is about a ninety-minute

interstate drive north of Milwaukee. It took a bit longer, however, when Al, Pete and Bill Lindemann began managing the Yankee American Circus in 1908. Like the Ringlings in Baraboo, the Sheboygan Lindemann brothers were well schooled in the circus business from an early age, organizing shows under a succession of titles. The three men presented their first performance using their surname as the Lindemann Brothers Circus in 1918. Changing the title again, the Lindemanns were known as Sells-Sterling from 1921 to 1938, when the Great Depression finally ended its run. During its heyday, Sells-Sterling ballooned into one of America's largest motorized venues, moving on dozens of trucks between cities. Sells-Sterling's twenty-nine-week route covered ten states in 1937.

Among the ten or so family members performing in the show were Sonya, Shirley and Peter, three grandchildren of Pete Lindemann. Sonya went on to produce *Circus Echoes*, a video about the family and its circus. She also donated numerous artifacts now displayed at the Sheboygan County Historical Society in Sheboygan. The family's contribution to America's entertainment scene has not been forgotten. The Lindemann brothers were inducted into Sarasota's Circus Hall of Fame in 1965.

Hi, There

French explorer Jean Nicolet was among the first white men to visit what would become Wisconsin. His canoe journey from Quebec to the Door Peninsula, a jut of land between Green Bay and Lake Michigan, took about ten weeks in 1634. Eight years after entering the bay, Father Barthélemy Vimont described how Nicolet was received:

> *They meet him; they escort him, and carry all his baggage. He wore a grand robe of China damask, all strewn with flowers and birds of many colors. No sooner did they perceive him than the women and children fled, at the sight of a man who carried thunder in both hands—for thus they called the two pistols that he held. The news of his coming quickly spread to the places round about, and there assembled four or five thousand men.*

Manners in the Woods

A logging camp mess hall usually could accommodate from thirty to fifty hungry men at a time, related logging historian Malcolm Rosholt. "No talkin'" was the rule because if conversation was allowed, the cooks and waiters would not have been able to communicate with one another over the noise. The men sat at narrow tables so that all of the food

was within reach, whether by grabbing or spearing with a fork or knife. In *The Wisconsin Logging Book, 1839–1939*, Rosholt retold the folk ballad "Frozen Logger," which satirized a logger's manners:

> *A 40-year-old waitress*
> *to me these words did say:*
> *"I see that you are a logger*
> *And not just a common bum,*
> *For nobody but a logger stirs*
> *his coffee with his thumb."*

Trade Goods

In 1809, Alexander Henry, the first English trader at Michlimackinac, wrote of his adventures in the Upper Midwest. His graphic memoirs about life in the northern wilderness were entitled *Travels to Mackinac*. Henry worked out of the fort between 1760 and 1776, running trade goods from Montreal through the Upper Great Lakes and on into the untamed wilds of Wisconsin and Minnesota. In his book, he related how goods were transported along the St. Lawrence River and then into Lakes Superior and Michigan.

> *The canoes which provided for my undertaking were, as usual, five fathoms and a half* [thirty-three feet] *in length and four-feet-and-a-half in their extreme breadth, and formed of birch-tree bark a quarter of an inch in thickness. The canoes are worked, not with oars but with paddles, and occasionally with a sail. To each canoe, there are eight men; and to every three or four canoes, which constitute a brigade, there is a guide or conductor. Skillful men, at double the wages of the rest, are placed in the head and stern. They engage to go from Montreal to Michilimackinac and back again, the middle-men at 150 livres* [$25] *and the end-men at three hundred livres* [$50] *each.*

The following provides the contents of one trade canoe making the voyage from Montreal to Michilimackinac in

1777 and on to trading posts on the Wisconsin frontier. This particular load was sent to David McCrea at Michilimackinac by outfitters William and John Kay of Montreal. The original inventory listed the goods by bale and even contained details about color and type of cloth. The items were packed in a number of bundles, so traders had a wide range of goods in each parcel. The inventory consisted of

> *128 blankets; sixteen cloth strouds at twenty-eight pounds; eight bunches of beads; sixteen gun barrels; 950 pounds of gunpowder; 168 pounds of soap; eight fuzils* [trade muskets]*; two pint jacks; 8¼ pounds of brass wire; twenty-four cutteaux croches* [knives]*; five sacks, musket balls; three quarts of shot; one basket with copper kettles; one large canoe kettle; cod lines for canoe; eleven ells sheeting for sails* [an ell is a old way of measuring length in textiles; equivalent to six handbreadths; it was typically about forty-five inches]*; thirty-six pounds of hide leather; cod lines for bales; 1½ ps* [pieces] *hessen for bales; and one skain Holland twine for bales.*

The list continues with

> *twenty-four half axes; two augers; one slater's hammer; one pick axe; two barrels port wine; eight gallons of spirits; one barrel, plus eight gallons of*

brandy; eight shot-bags; fifteen empty barrels; one fuzil case; one soap case; twenty-eight pounds gum for canoe repairs; one canoe and poles; one axe for canoe; one spunge and canoe awl; 122 pounds of Irish pork; 800 pounds, plus two bags, of biscuits; six bags for biscuits; three bags for pork; a quarter pound of shot; seven cutting knives; one piece of Russia sheeting, which is a plain weave hemp linen; and fourteen yards of cotton.

THE FIRST WELSHMAN ARRIVES

The first Welshman to settle in what came to be called the Welsh Hills of Waukesha County was John Hughes, who arrived in 1840. He purchased 240 acres in Genesee Township, land noted for its rich, deep soil. His acreage included woodlots, a flower-bedecked prairie needing plowing and plenty of fresh water. He named his farm *Nant-Y-Calch*, Welsh for "Lime Brook," the name given to his farm by government surveyors.

THREE-RING MUSEUM

The Circus World Museum, operated by the Wisconsin Historical Society and a National Historic Landmark, is a sixty-four-acre complex of buildings in Baraboo that

formerly housed the old Ringling show. The structures, including the Elephant Barn and Camel House, are along the north bank of the Baraboo River. The barns date from 1897 through 1918. The remains of a footbridge, which employees took across the river, can still be seen. On the south side of the river are displays of circus train cars, plus a hippodrome for entertainment and related exhibits. Loading and unloading the flatcars by means of horses is always a crowd pleaser. In the summer, handlers lead the museum's performing elephants into the water to splash around and cool down.

After thirty-three years as the Ringlings' personal attorney, John M. Kelley wanted a place to memorialize his circus friends. When he finally retired in 1954, Kelley incorporated the Circus World Museum as a historical and educational facility that opened on July 1, 1959. Circus World Museum encompasses thirty permanent structures, including four more of the original winter quarters buildings and a railroad siding with authentic train cars from various shows. The first museum director, Charles (Chappie) Fox, carried on Kelley's dream, writing numerous books about the circus, the Ringlings and related show business subjects. Fox took charge of the museum in 1960 and greatly expanded its operations.

The Circus World Museum's collection of circus artifacts remains among the largest in the world, with more than 210 original wagons and vehicles once used by American, English and Irish shows. A wagon shop on

the grounds keeps the century-old collection in top shape. Its archives house almost ten thousand posters, including one Buffalo Bill Wild West poster that is nine feet high and seventy feet long. In addition to the artwork are journals, manuscripts, business records, show programs, photographs and negatives.

In 1963, Fox and Milwaukee public relations/advertising master Ben Barkin began the Great Circus Parade using many of the wagons from Baraboo. Fox and Barkin convinced the Schlitz Brewing Company to sponsor the event. The parade was staged along a three-mile route in downtown Milwaukee until 1973 and then shifted between Baraboo, Chicago and Milwaukee from 1980 to 2005. In 1985, the event became known as the Great Circus Parade, running to 2005.

Wagons were brought to Milwaukee by train, much like in the good old days, with a circus lot set up on the shore of Lake Michigan. Tented performances, camel and elephant rides, daredevils shot out of cannons, Wild West shows and other entertainments were part of the fun. After a hiatus of four years, another parade was staged in 2009.

When circus impresario Fox died in 2003, several colorful antique circus wagons pulled by Percheron draft horses led the funeral cortege to the Baraboo cemetery. At his death, newspaper headlines blared, "America's Ringmaster Steps Out of the Spotlight."

Cold, Hard Politics

It seemed that almost every time early Wisconsin politicians met to talk shop, the weather was frosty or snowy.

The Wisconsin Territorial Legislature Council initially huddled in tiny Belmont, in southwestern Wisconsin's Lafayette County. The two buildings in which the sessions were held from October 25 to December 9, 1836, later served as the residence of territorial Supreme Court chief justice Charles Dunn and eventually even became livestock barns. The structures were purchased and renovated by the Wisconsin Historical Society in 1994.

The lawmakers, shivering in the cold that autumn, still managed to pass forty-two pieces of legislation, set up a court system, discuss road building and encourage the construction of railroads. The politicians slept in the same buildings where the meetings were held, snuggling under blankets and overcoats since "the accommodations were most miserable," according to Green Bay delegate Ebenezer Child.

Rather than establish a permanent capital in out-of-the-way Belmont, a majority of delegates voted to make Madison the seat of Wisconsin's government, despite protests by some politicians pitching their own communities. Finalization of the deal immediately launched a rush by eager speculators to the government land office in nearby Mineral Point. The town plat of Madison was divided into

twenty shares, and Green Bay's Child was offered one lot for $200. He refused, saying:

> *I presume that was done, thinking if I accepted it, that I would vote for Madison for the capital; I reject the offer with disgust and felt better satisfied than I should to have sold myself for the twentieth part of Madison. When I returned to Green Bay, my friends there were well pleased with the course that I had taken.*

It was also freezing when the Wisconsin legislature eventually met in Madison, holding a session on November 26, 1838. The capitol building itself was not yet ready for occupancy, so the politicians gathered in the drafty basement of the old American House hotel. Despite his initial objection to siting the capital in Madison, Child did come down from Green Bay to attend the meetings. He described the scene:

> *We adjourned from day to day, until we could get into the new capital* [sic] *building. At length, we took possession of the new Assembly Hall. The floors were laid with green oak boards, full of ice; the walls of the room were iced over; green oak seats, and desk made of rough boards; one fire-place and one small stove. In a few days, the flooring near the stove and fire-place so shrunk on account of the heat, that a person could run his hands between the boards.*

> *The basement story was all open, and James Morrisons's large drove of hogs had taken possession; they were awfully poor, and it would have taken two of them, standing side by side, to have made a decent shadow on a bright day.*
>
> *We had a great many smart members in the House…When members of this ilk would become too tedious, I would take a long pole, go at the hogs, and stir them up; when they would raise a young pandemonium for noise and confusion. The speaker's voice would become completely drowned, and he would be compelled to stop, not, however, without giving his squealing disturbers a sample of his swearing ability.*

The weather continued to be so cold that the ink froze. Child wrote:

> *So when we could stand it no longer, we passed a joint resolution to adjourn for twenty days. I was appointed by the two houses to procure carpeting for both halls during the recess; I bought all I could find in the Territory, and brought it to Madison and put it down after covering the floor with a thick coating of hay. After this, we were more comfortable.*

Last Man Hanging

After Kenoshan John McCaffary drowned his wife, Bridget, on July 23, 1850, he earned the distinction of being the last man executed under Wisconsin law. His trial began on May 6, 1851, and he was convicted of murder on May 23. McCaffary was hanged from a tree in front of the Kenosha County Courthouse as a crowd of some three thousand persons watched. For more than twenty minutes, he swung at the end of the rope and slowly strangled. After his death, he was buried at Green Ridge Cemetery on Kenosha's outskirts. After the gruesome execution, death penalty opponents were able to get legislation passed outlawing capital punishment in Wisconsin.

On July 12, 1853, Governor Leonard J. Farwell signed the legislation into law and replaced the death penalty with life imprisonment. The arm and leg restraints that bound McCaffary are in the collection of the Wisconsin State Historical Society (ask to look at museum objects #1976.249.1–2).

Sometimes revenge was not state sponsored. Rock County farmer Andrew Alger was stabbed to death in 1854, killed by former convict David Mayberry. Mayberry, in turn, was hanged by a mob of riotous lumberjacks. Afterward, the vigilantes tore off the limb of the tree on which Mayberry's body dangled and stole pieces as souvenirs.

A year later, in 1855, the situation underlying another lynching was fueled by misunderstandings between

German-speaking immigrants and non-Germans. George DeBar who had mental and physical disabilities, became involved in a fight with a German farmer with whom he worked. Apparently, there was a misunderstanding over wages being owed, and DeBar stabbed and wounded John Muehr, his employer, and his wife, Mary. He then killed another hired man, Paul Winderling. Hundreds of German settlers from the area flocked to the county jail to watch DeBar's indictment. The state militia was on hand to control the crowd, which did not have a lot of faith in its adopted country's judicial system.

But many of the soldiers were also of German heritage and faded into the background rather than face off with their countrymen. The mob surged toward DeBar when he was led out of the courthouse to be taken back to jail after a coroner's inquest. A *New York Times* report said that "ten old ladies with broomsticks would make a more forcible military power than they." DeBar was attacked and beaten badly before being lynched by those whom local newspapers later called "hideous monsters."

When Milwaukee became a village in 1834, the Common Council hired Sciota Evans as town constable to keep the peace. But even he was unable to prevent the city's first murder, which occurred in November 1836. A Native American named Manitou was killed by Joseph Scott and Cornelius Bennett at what is now the southeast corner of Michigan and East Water. The killers escaped from jail and

hightailed it out of town. Scott was ultimately hanged in Indiana for another crime, and Bennett was never heard from again.

DISTAFF SIDE

Women have long been community and business leaders in Wisconsin. Among the first female entrepreneurs was Mrs. Anne Pickett, who made history in 1841 when she established the state's first commercial cheese factory in Fond Lac County. At first, this hardworking lady worked out of her kitchen in a log cabin, using milk she gathered from neighbors' cows.

It wasn't until seventeen years later that a man, John J. Smith, obtained a cheese vat and made cheese at his home in Sheboygan County. But to give more men their dairy due, Smith's brother, Hiram, a farmer who served on the University of Wisconsin Board of Regents, established Wisconsin's first full-scale cheese factory. It was the first not operated as a cottage industry. He purchased milk from dairy farmers or processed their milk in exchange for a percentage of the finished cheese.

But back to women. One of the most ardent supporters of women's right to own their own businesses and to demand equal protection under the law was Mathilde Franziska Giesler. Born on April 3, 1817, in

Lerchenhausen, Westphalia, she grew up on the estate of her grandfather and was highly educated. Giesler married Alfred von Tabouillot, a wealthy dealer in high-end wines; however, the marriage ended in divorce. An extended legal battle over custody of their infant daughter led her to become a staunch advocate of women's rights since the laws of the time were skewed more to favoring men than women.

Seeking a platform for her views, Giesler founded the first German feminist newspaper, *Frauen-Zeitung*, in September 1848. Swept up in the revolutionary movement of the period in Europe, she fled to safety in the United States. Attracted to the forward-looking German Social Democratic movement, she moved to Milwaukee in March 1852. Soon afterward, she started the first feminist journal published by a woman in America, the *Deutsche Frauen-Zeitung*. Through her advocacy of women's rights, Giesler became a close friend of activists Susan B. Anthony and Elizabeth Cady Stanton. Giesler also founded a school for girls in Milwaukee, which she managed until her death on November 25, 1884.

Yet women continued to find their career paths blocked. A motion in the 1870s to allow Miss Rhoda Lavinia Goodell to practice law demonstrated the challenges that nineteenth-century women faced trying to enter traditionally male professions.

Goodell was a Janesville attorney and the first woman to apply for admission to the bar of the Wisconsin

Supreme Court. In that era, attorneys needed permission to both practice before the state's high court and simply practice law. In the first case, her application was denied in a unanimous opinion by a three-justice panel. Chief Justice Edward G. Ryan wrote the opinion issued in February 1876.

Ryan pontificated about why women were not suited to practice law—because of "the peculiar qualities of womanhood, its gentle graces, its quick sensibility, its tender susceptibility, its purity, its delicacy, its emotional impulses, its subordination of hard reason to sympathetic feeling." He summed up his argument by writing:

> *It is public policy to provide for the sex, not for its superfluous members; and not to tempt women from the proper duties of their sex by opening to them duties peculiar to ours. There are many employments in life not unfit for female character. The profession of law is surely not one of these.*

Later, Goodell recalled that Ryan "bristled all up when[ever] he saw me, like a hen when she sees a hawk, and did not recover his wonted serenity during my stay. It was fun to see him! I presume I was the coolest person present."

However, three and a half years later, on appeal, the court voted four to one in favor of admitting Goodell. Justice Orsamus Cole wrote the majority opinion granting her admission, while Ryan still dissented.

This action was followed by legislation that outlawed denying bar admissions because of an applicant's gender. Unfortunately, after all her hard work, Goodell died at age forty the following March, cutting short her budding legal career.

Bounding Waves

Lake Michigan has long been a draw for excursionists, whether paddling around in rowboats or sailing offshore. It could be a dangerous place for sport, however, as evidenced when a group of young Kenoshans were caught in a squall that threatened to capsize their craft in the late 1890s. Safely back on shore, Charles W. Bishop told of their adventures in the next day's newspaper:

> *We sailed away about 4 o'clock and when about five miles from shore and half way between Racine and Kenosha, the storm struck us. It blew great guns and we scudded along under bare poles…We enjoyed ourselves hugely. We sung all the college songs, from "Upidee" to "Mary Had a Little Lamb"…The young ladies carried themselves bravely. If they had fear, they didn't show it. Meantime our friends on shore were just crazy about us. They had four tugs plying up and down the lake and the two life-saving crews were out after us. I was a little scared after the squall when the rudder*

broke, but we hauled it up and fixed it right there. The only mishaps were the scalded noses and faces of the party. We're going again if the Kenosha girls' parents will let them.

BYE-BYE BIRDIE

Babcock, Wisconsin, is noted for being the site of the last known sighting of a passenger pigeon in the wild. The now-extinct species was a game bird in the 1800s, and its migratory flights darkened the sky as the birds passed over. Early conservationist John Muir wrote that he saw flocks

> *so large that they were flowing over from horizon to horizon in an almost continuous stream all day long, at the rate of forty or fifty miles an hour, like a mighty river in the sky, widening, contracting, descending like falls and cataracts, and rising suddenly here and there in huge ragged masses like high-splashing spray.*

At one time, it was estimated that there were some three billion of these pigeons, making up 40 percent of bird population of the United States. In 1871, one nesting alone was counted at 136 million birds, blanketing more than eight hundred square miles of southern Wisconsin. The state was on their flyway, so hunters had a grand time blasting them from the sky, both for food and sport. Many

carcasses were sold as delicacies in Chicago throughout the 1870s.

It was presumed that the birds would last forever—a false premise, indeed. As timber for nesting was logged and adult birds slaughtered before they could breed, the passenger pigeon was socked by humankind's one-two punch.

The last passenger pigeon in the wild was killed by a hunter near Babcock in 1899. Wisconsin's last four captive pigeons died at the Milwaukee County Zoo between 1908 and 1909. In 1914, Old Martha, the world's last remaining passenger pigeon, died at the Cincinnati Zoo.

With the demise of the passenger pigeon, prairie chickens flourished, and Wisconsin became noted for its abundance of these birds. Special trains for hunters again converged on Babcock. Among them was Wisconsin's governor, J.J. Blaine, who chartered several coaches for his shooter friends during his term in the early 1920s. However, overhunting also threatened this bird species, especially as much of its habitat had been plowed under for farming.

In 1905 and 1907, laws restricted the hunting of these birds. By 1917, Wisconsin had initiated a four-year moratorium on them, with the ban extending for eight years in Portage County. This region eventually became home for what was to become Wisconsin's premier greater prairie chicken habitat management effort, called the Buena Vista Grassland. The site covers about eleven thousand acres and is visited by hardy birdwatchers who love to view the chickens' mating dance and hear the booming male

choruses. From 1921 until 1955, when the last prairie chickens were hunted in Wisconsin, the state subsequently permitted only short open-hunting periods.

In lieu of hunting, bird fans can attend the Prairie Chicken Festival held annually during the height of the mating season each April at various locales throughout central Wisconsin.

Grand Old Man

Zalmon G. Simmons was born in Euphrates, New York, on September 10, 1828, and came to Wisconsin when he was fourteen. Simmons settled in Southport, as Kenosha was known at the time, and grew up on a farm. He started a distinguished business career in the community by clerking at Seth Doan's General Store at age twenty-one. Within sixteen months, he purchased the business. Within a few years, the ever-industrious Simmons owned a telegraph company and a cheese box factory, as well as a plant that built wooden insulators.

But his biggest claim to entrepreneurial fame was founding what became the world's largest manufacturer of mattresses. After almost 150 years, Simmons Mattress is still in business, making such iconic brands as Beautyrest, My Dream Bed and ComforPedic by Simmons.

Simmons wasn't merely content to be a business whiz. For forty years, he served as president of the First National

Bank of Kenosha. In his spare time, he even rescued a local railroad from bankruptcy. Simmons also dabbled in politics, serving as a state legislator in 1865 and as Kenosha's mayor in 1884.

He was noted for mentoring young businessmen who went on to found numerous Kenosha manufacturing companies. Noted for his philanthropy, Simmons supported the Kenosha Hospital, the public library, the Unitarian Church and individuals in need.

Fondly nicknamed "Kenosha's Grand Old Man," his *Kenosha Telegraph/Courier* obituary of February 17, 1910, told how the locals knew him for his daily walks from his home on Prairie Avenue to his downtown office. Even from a distance, his white beard, stovepipe hat and "stately manner" were easily recognizable features.

Dairy Bar

Wis. Stat. ch. 279, sec. 352-365 [Laws of 1925]*: It shall be unlawful for any person, firm or corporation, by himself, his servant or agent, or as servant or agent of another, to manufacture, sell or solicit or accept orders for, ship, consign, offer or expose for sale or have in possession with intent to sell, any article, product or compound which is or may be used as a substitute for butter and which is made by combining with milk or milk fats or any of the derivatives of either any fat,*

FORGOTTEN TALES OF WISCONSIN

oil or oleaginous substance or compound thereof other than milk fat.

The Wisconsin Supreme Court case of *John F. Jelke Company v. Emery* centers on that quirky Wisconsin law making it a crime to manufacture or sell margarine in the state. The legislature passed the law quoted above to aid the state's powerful dairy industry.

Yet a unanimous court decision found that the legislature had no power to attempt to regulate competition, giving one industry an advantage over another, affirming the ruling of Judge August C. Hoppman of the Dane County Circuit Court. Supreme Court justice Marvin B. Rosenberry wrote the opinion voiding Chapter 279, Section 352.365 of the Laws of 1925.

John Quincy Emery was dairy and food commissioner for Wisconsin and argued that it was his duty to enforce Chapter 279. Subsequently, he petitioned the court to prohibit the respondent, John F. Jelke Company, from producing and selling oleo in the state.

Justice Rosenberry's majority opinion called Chapter 279 an "exercise of the police power" in that it prohibited the operation of a legitimate business and the sale of a product widely accepted as wholesome. He stated that "prohibition can only be justified upon the ground that it is necessary in order to protect the public health, public morals, public safety, prevent fraud, or promote public welfare."

Rosenberry referred to many cases that presented evidence that oleomargarine was accepted as a "nutritious, wholesome, healthful food" that did not endanger public health or safety. Therefore, he asserted, the prohibition of its production and sale was not justified.

In addition, although the court agreed that oleo was a substitute for butter, it determined that the oleomargarine industry marketed and sold the product based on its own merits. It didn't show evidence of fraud. Rosenberry wrote that there was "certainly no question of morals" regarding the issue.

Considering the petitioner's argument that the sale of oleomargarine created "unfair competition" for Wisconsin's dairy industry, Rosenberry concluded that:

> *From the standpoint of constitutional right, the legislature has no more power to prohibit the manufacture and sale of oleomargarine in aid of the dairy industry than it would have to prohibit the raising of sheep in aid of the beef-cattle industry or to prohibit the manufacture and sale of cement for the benefit of the lumber industry.*

With the ruling, the Supreme Court determined that prohibiting the sale of oleomargarine was to the "advantage to a particular class of citizens and to the disadvantage of others." Therefore, the court said that it had a duty to nullify the "oppressive acts" of legislation.

Falling from the Sky

Thirty-six persons died due to aviation accidents in Dane County from 1951 to 2009, according to the *Wisconsin State Journal/Capital Times* library. A number of deaths involved military aircraft. The toll could have been higher, but only two persons were injured when an F-51 Air Force fighter plane crashed in flames at Truax Field on September 9, 1952. The area was sprayed with six hundred rounds of .50-caliber slugs, which blasted nine nearby houses and wounded two civilians on the ground.

Others were less fortunate. In February 1952, an F-80 Shooting Star crashed in a farm field near Cottage Grove, killing the pilot. On September 21, 1952, a C-47 transport plane crossed Highway 51 while approaching the runway at Truax Field and smashed into an auto on the highway, killing all four of the car's occupants. In January 1953, four jet interceptors took off from Truax Field in a snowstorm. None was able to find the field during the return trip; all ran out of fuel and crashed. Two pilots bailed out while two pilots were killed.

On November 3, 1953, an F-86 Sabrejet and F-89 Scorpion collided in midair. One plane attempted to make it back to Truax but crashed in a farm field near Deerfield, injuring the pilot. The other plane crashed near Watertown, injuring the pilot and killing the radar operator. On November 23 that same year, an F-89C Scorpion jet crashed in the arboreous shoreline of Lake Wingra,

killing the pilot and radar observer. In June 1964, an F-89 Scorpion jet crashed during takeoff at Truax, killing the radar observer.

In May 2008, fifty years after Gerald Stull died when his plane was ditched in Lake Monona, the Dane County Board honored him, a U.S. Air Force flier, for his valor and sacrifice. On May 5, 1958, Stull piloted his $2 million F-102A jet fighter away from homes in neighborhoods near the lake and crashed it into the water. The plane went down just west of Olbrich Park, probably saving countless lives by hitting the lake. Stull, twenty-six, had been on a routine training flight from nearby Truax Field and was returning to the base when he reported that his plane had developed engine problems.

A Lot of Bull

Elephants, called "bulls" regardless of sex, have always been integral to the circus. The "ponderous pachyderms" were the object of admiration and awe when they ambled through town in a parade or performed a routine in the ring. One of the most famous, Ziegfeld or "Ziggy," earned headlines in Milwaukee during Prohibition when he got his owners into trouble.

The big bull attracted fans wherever he resided. At one time, he was the largest elephant in the country, weighing in at 10,096 pounds and standing ten feet, one inch at the

shoulder. Ziggy was named for his first owner, showman Florenz Ziegfeld, the famous Broadway impresario who launched the Ziegfeld Follies revue in New York City.

Ziggy was shipped to America from Asia by circus owner John Ringling when the animal was one year old. He was sold to Ziegfeld, who gave the elephant to his six-year-old daughter as a Christmas gift. The elephant was driven from the dock to Ziegfeld's home in the backseat of a taxi. At a holiday party, however, the little elephant ate everything in sight, including all of Mrs. Ziegfeld's houseplants and the cookies and ice cream on the table. He galloped through the greenhouse, playfully lumbering after the children, who fled screaming into the yard.

That was enough. Ziegfeld sold the elephant to Leo Singer, who managed a touring variety show that featured little people. On the road, Ziggy became a gentleman and generally behaved himself. He grew larger and larger as he traveled around the world with the troupe. Trainer Charles Becker, who was also a dwarf, taught Ziggy to smoke cigarettes through a foot-long holder and play "Yes, Sir, That's My Baby" on a giant harmonica made especially for him. When Becker shouted, "Shake it up, Ziggy!" the elephant danced, wiggled and snorted with his trunk raised high in the air.

One time, when the Singer entourage was in Spain, the stage collapsed under Ziggy's weight, sending the big animal and the performers tumbling into the basement. No one was hurt, and the elephant thumped out of the wreckage and danced until the audience calmed down.

Now to Milwaukee. While the entertainers stayed at a downtown hotel, Ziggy spent the night in a doctor's stable. Becoming restless without his small friends, he pulled his restraining chain out of the wall, which promptly collapsed. The wall was actually a loosely constructed barrier hiding a secret storeroom packed with 130 cases of bootleg whiskey stored illegally by the doctor. The physician was the brother of a top Milwaukee police official. Ziggy and the little people left town in a hurry the next morning.

Ziggy's performing career didn't end until 1936, when he appeared in San Diego. His trainer, Becker, became ill and was replaced by a substitute. The elephant didn't like the newcomer, and he went on a rampage from the stage. In addition to smashing the props and much of the theatre, Ziggy tossed a trombone player from the orchestra pit thirty feet across the room. That display of temper resulted in him being sold to Chicago's Brookfield Zoo for $800. The zoo director was praised for acquiring such a rare, talented, harmonica-playing elephant. He responded, "Yeah, volcanoes are rare, too, but who wants one?"

In 1941, Ziggy attacked another trainer and was subsequently brought inside his elephant house, where he lived in solitary confinement for the next three decades. In a campaign led by schoolchildren, he was eventually allowed into a new pen with plenty of sunlight. He died in 1975, injured after falling into a moat that surrounded his compound. Ziggy's remains were given to the Field Museum of Natural History in Chicago.

In other elephant shenanigans, Barbara, a Carson & Barnes circus elephant, eluded her trainer on August 8, 1977, and escaped. She went for a walk through town, tromping on flower beds before being returned to the circus. Barbara garnered more headlines later that month when she thundered through the Maplewood care center in Sauk City on August 28.

She led police on a four-mile chase before being recaptured. None of the ninety-one elderly residents of the home was injured during her visit. But they were certainly surprised when the thirty-six-year-old, six-ton visitor smashed through a four-foot-high plate-glass window and an inside wall. She then meandered down the hallway and out the care center's back door. Tillie

Nolden, seventy-one, was having lunch in bed when Barbara wandered past the open door to her room. "I thought I was surely going mad," she told an Associated Press reporter. "Did I really see an elephant?"

In the course of her adventure, the ten-foot-tall Barbara knocked down the building's low-hanging light fixtures and ripped out the fire alarm system that ran along the ceiling.

BLAINE GAME

Contentious John James Blaine was the twenty-fourth governor of Wisconsin, a hardened political operative who moved on to become a United States senator. He was born on May 4, 1875, in the Sauk County village of Wingville, dying April 18, 1934, in Boscobel, Wisconsin, where he is buried.

After serving in the state senate and as attorney general, Blaine was the Republican governor of Wisconsin from 1921 to 1927. A flap arose in 1925 over Blaine's name when the *Fennimore Times* published a biography of the then governor, stating that his family was really "Blain." The biographer also asserted that the governor was fifty-two years old, not fifty. Allegedly, Blaine had misrepresented his age to accommodate his title as "the Boy Mayor of Boscobel," a position he held before becoming governor shortly after graduating from Northern Indiana University Law School in 1896.

In a letter to Henry E. Roethe, *Times* editor, demanding corrections, Blaine retorted:

> *I therefore advise you, first, as to my age. I can scarcely have any personal recollection thereof, inasmuch as I was very young on the day I was born. I took the name and age given me by my parents, and I believe them, and evidentiary documents relating thereto convince me that my father and mother were not impostors.*

In 1926, he defeated the Progressive Republican senator Irvine Lenroot in the primary. He went on to win the general election with 55 percent of the vote against both Democrat and Socialist candidates.

His legislative legacy includes him being the only senator to vote against ratification of the Kellogg-Briand Pact, which was approved eighty-five to one. The pact was a multinational treaty that prohibited the use of war as "an instrument of national policy." Despite his negative stand, Blaine did force the Senate to add a reservation that the treaty would never infringe on America's right of self-defense and that the United States was not obliged to enforce the treaty by taking action against those who violated it. The treaty still stands as the legal basis for the philosophy that there can be a "crime against peace." This became the legal basis for the Nuremberg Trials after World War II.

Perhaps redeeming himself, Blaine was also the author of the Twenty-first Amendment, repealing the Eighteenth Amendment, which had prohibited the manufacture and sale of intoxicating liquors. Blaine, speaking on behalf of the Senate Judiciary Committee, defended a clause in the proposed amendment by stating that there was still protection to states choosing to remain dry. In one speech, he said, "I am willing to grant to the dry States full measure of protection, and thus prohibit the wet States from interfering in their internal affairs respecting the control of intoxicating liquors."

In 1932, Blaine was defeated in the Republican primary by John B. Chapple, who was in turn defeated in the general election by F. Ryan Duffy as massive Democratic victories swept national elections that year.

Fluffy Flyboys

Wisconsin schoolchildren collected 283,000 bags of milkweed fluff for use in life jackets during World War II. Traditionally, fibrous kapok had been used for this purpose, but that material became unavailable when the Japanese occupied Indonesia, where the tropical tree was mostly grown. Using the fluff was nothing new; the state's Native Americans had long utilized the fluffy seed as insulation in their moccasins.

Travelin' Men

Jean Claude Allouez, a French Jesuit, spent seven years learning Native American languages and cultures so that he could better serve as a missionary in Wisconsin. He regularly reported on his travels throughout the region in *Jesuit Relations*, published annually back home in France. Between 1669 and 1670, Allouez traveled along the wide waters of Lake Winnebago, Wisconsin's largest inland body of water, which stretched thirty miles long and eleven at its widest point.

After crossing the lake, Allouez entered the Upper Fox River, canoed down through Lake Butte des Morts and arrived at the entrance to the Wolf River. From there, he made his way to an Outagami village, where he remained for a time to preach.

> *On the twentieth which was Sunday, I said mass, after voyaging five or six leagues on the lake, after which we came to a river flowing from a lake bordered with wild oats; this stream we followed, and found at the end of it the river that leads to the Outagamis, in one direction, and that which leads to the Machkoutenck in the other. We entered this first stream, which flows from a lake; there we saw two turkeys perched on a tree, male and female, resembling perfectly those of France—the same size, the same color, and the same cry. Bustards, ducks, swans and geese are in great number on all these lakes*

*and river, the wild oats, on which they live, attracting
them thither. There are large and small stags, bears and
beavers in great abundance.*

Peter Pond was a New England trader who spent many years in Wisconsin, visiting various tribes. In his autobiography, he tells of a trip up the Fox River between 1773 and 1774, making his way to Prairie du Chien. Although his phonetic writings were not polished, containing misspellings, a lack of punctuation and grammatical errors, Pond still was a marvelous storyteller, writing in his own East Coast, colonial-era speech pattern:

At the End of two Days we aSended the fox River til we Came to a Villige which Lises on the East End of a Small Lake that Eties [empties] *in to the fox River. these People are Cald Pewans (Puans) & the Lake By the Same Name. these People are Singelir from the Rest of thare Nighbors thay Speake a Hard un Corth* [uncouth] *Langwige Scarst to be Larnt by Eney People. they will not aSosheat with or Convars with the other tribes Nor Intermarey among them. I Enquird in to the Natral Histrey of these People when I was at Detroit of the Oldest and Most Entelaget french men Who had Bin aquantd with them for Meney Years. the Information amounted to this that they formely Lived west of ye Miseiarey* [Missouri River] *that they Had Entarnal Disputes among themsel*[ves] *and Dispute with the*

Naitos about them at Length thiare Nighber in Grat Numbrs fel apon them and what was Saved flead across the Misesurea to ye easter and Over the Massappey and to this Lake whare they now live. there they met with a tribe of Indian Who Suferd them to Seat Doun in it was asis Suposed the fox Nation who leved Near them.

DANGEROUS HEROISM

Fires have always made news, whether for today's television broadcasts or early newspapers. The *Stevens Point Journal* of November 20, 1909, reported on one notable blaze:

> *Fire broke out in a barn in the rear of William Pattee's grocery store at Endeavor one day last week, which at one time threatened to destroy the business portion of the village. By valiant service on the part of the bucket brigade, however, the flames were confined to the barn which was destroyed. The seriousness of the conflagration was no doubt relieved by the heroic work of Mr. Pattee and a neighbor, Mr. Smith, who rushed into the burning building and rolled out a big barrel of gasoline, which had been placed there a day or two before. Both men were slightly singed by the flames while attempting to rescue the barrel. Mr. Pattee is a brother of Frank Pattee of this city and resided for many years in Stockton and in this city.*

The Big Picture

The panorama painters of the nineteenth century filled a little-known niche in Wisconsin's vibrant art scene. These craftsmen were mostly Germans who created giant dioramas of historical scenes. Some of the pieces covered eighteen thousand square feet of linen, with canvases ranging up to fifty feet high and four hundred feet around. Usually, a team directed by the master painter worked on a project, with one person doing the landscape, another placing the human figures and another doing animals. The paintings were displayed in buildings constructed specifically for their viewing.

The siege of Paris in 1871 during the Franco-Prussian War actually spawned this new industry. When the city fell to the Germans, patriotic Milwaukeeans of the Teutonic persuasion, which constituted almost half the population, gleefully celebrated. Although French trappers and tradesmen had founded the Wisconsin city, anyone of such Gallic background laid low, especially on January 28, when the French capital surrendered.

According to the *Milwaukee Sentinel*, the celebration lasted all night, with gunfire and fireworks blasting away the stars. The paper reported that a carpenter named Olson was almost hit by a rifle ball while he was working late on repairs to a schooner tied up at a Milwaukee River dock. Another ball hit the State Street Bridge, and there were police reports from around the city of other near misses as

German brass bands and gun-toting revelers marched up and down.

To commemorate the bravery of Paris's defenders, a father-son team of French painters named Philippoteaux manufactured a giant painting of the city siege for the Paris Fair of 1878. Not to be outdone, German painters did the same and sent their version of the conflict to New Orleans for the 1884 Cotton Exposition. William Wehner, a Chicago promoter, saw that massive work and decided to combine his business acumen with German artistic skill. What better place would there be to launch his panorama company than in Milwaukee, considered America's German Athens. As such, notable painters like Frederick William Heine, were hired to create these panoramas as a precursor to the days of movies and television.

Richard Lorenz was noted for applying his paint with large, flat knives instead of brushes because his works were so huge. Another well-known painter was Henry Vianden, who became a renowned art teacher. One of his pupils was Milwaukee-born Carl Von Marr, considered to be among the best of the genre. His masterpiece, *The Flagellants*, was completed in 1889, measuring fourteen by twenty-five feet. It won a top art prize at the 1893 Chicago World's Fair. The massive piece, Wisconsin's largest framed painting, is now exhibited at the Museum of Wisconsin Art in West Bend. From 2008 to 2009, it was proudly shown in Munich's Haus der Kunst museum to rave reviews.

The only remaining known Milwaukee-made panorama is *The Battle of Atlanta*, now housed in Atlanta. After being showcased by a circus, the depiction of the bloody Civil War fight was placed in the Cyclorama, built in 1921. The circumference of the giant work is 358 feet, covering 15,030 square feet and weighing more than ten thousand pounds. Under the exacting eye of Heine and August Lohr, Milwaukee's American Panorama Company produced the impressive rendition. When it was first displayed, the then-living Civil War veterans or their widows escorted visitors around the site and explained the action depicted on the canvas. When the film *Gone with the Wind* opened in 1939, leading actor

Clark Gable toured the Cyclorama, supposedly saying that it would "be more magnificent" if he were in it. Subsequently, his face was painted on one of the dying Confederate soldiers.

Beertown's Gangbusters

When Milwaukee officially incorporated as a city, it remained rough and ready around the edges. Subsequently, the mayor appointed a city marshal, who was backed by an elected Milwaukee County sheriff. But neither the marshal nor the sheriff had enough officers to keep a lid on street crime during the 1840s and early 1850s.

Businessmen complained, housewives fretted and the general population grumbled about the thieves, pickpockets and thugs hanging around town. The situation changed when Herman L. Page, a former deputy, was elected sheriff in 1853. He was successful in catching several robbers but realized that he still needed additional assistance. Page knew a farmer and ex-cop named William Beck living near Granville, a village to the west of Milwaukee. Beck had been a detective on the New York City police force before moving to Wisconsin. Beck agreed to become a deputy after Page pleaded with him to serve. With his experience in law enforcement, the new officer immediately made a name for himself in snaring some of the more brazen scofflaws.

On September 3, 1855, an ordinance was introduced for creating a police force and was soon passed by an eager Common Council. On October 4, 1855, a proud new Milwaukee Police Department began functioning. The erstwhile Beck was chosen as chief of police by Mayor James B. Cross and given the unanimous backing of the council, which offered him a salary of $800 per year. For his patrolmen, Chief Beck selected six husky men for their size and fighting ability. In the rough back alleys of early Milwaukee, it was usually necessary to whip a miscreant before arresting him. Nobody was undercover in those days because the officers were easily identified with their black eyes, bruises and split lips. The first brawlers on Beck's force were Fred Keppler, John Hardy, George Fische, James Rice, L.G. Ryan and David Coughlin, each earning $480 a year. Eventually, the force grew to twelve men.

Muscles and knuckles were sometimes not enough for even the toughest officers. A major riot occurred in Milwaukee during 1861, in the aftermath of a national financial crisis that resulted in a number of bank closings and depositors losing everything. As a result, thousands of angry workmen left their factories on June 21 and stormed downtown to retrieve what cash they could.

Led by a thumping brass band, they charged up to the Wisconsin Marine and Fire Insurance Company. They confronted owner Alexander Mitchell, a wily, Scottish-born financier who came outside to talk with the crowd. Stones

began flying, and the banker retreated inside, scooping up as much gold and valuable coins as he could. He scampered out a back door, boarded a steamer in the Milwaukee River and bobbed safely offshore on Lake Michigan until the situation quieted down.

That, however, took several days. In the meantime, Mitchell's bank and the State Bank of Wisconsin were torched by the crowd. Mayor James Brown called out the Montgomery Guards, a volunteer company of rookie soldiers who unfortunately weren't issued ammunition with their weapons. When this became known, the rioters easily chased them away. It took sprays from fire department pumper wagons and a bayonet charge by another military unit, Hibbard's Zouaves, for order to be restored. For

several weeks, armed soldiers patrolled Milwaukee with loaded cannons at strategic intersections.

Once Mitchell returned to shore, he went on to found the Chicago, Milwaukee & St. Paul Railway, serving as president from 1864 to 1887. Through his wheelings and dealings, he became one of the wealthiest men of his generation in the United States. Mitchell's mansion across from the Milwaukee County Courthouse is now the Wisconsin Club. His grandson, Billy Mitchell, is regarded as the father of the U.S. Air Force.

Madison's Murder Mystery

Annie Lemberger's murder in September 1911 is still listed as unsolved after more than a century. The heinous killing occurred in Madison's Greenbush neighborhood, a pleasant, tree-lined, working-class area bounded by Regent Street and West Washington Avenue.

Annie was only seven when her battered body was found floating in Monona Bay. Initially, a neighbor had been suspected, and her father was later implicated. However, both were exonerated, and the killer remained at large.

The controversy over who might have killed the little girl, the accusations and the subsequent trials made the case one of the most notorious in Madison's history. The two local newspapers, the *Wisconsin State Journal* and the *Madison Democrat*, battled for readers by using more and

more bombastic headlines. "The fiend must be found," proclaimed the *State Journal*.

The neighbor, John A. (Dogskin) Johnson, was only six weeks out of prison and was considered the neighborhood layabout, making him a prime suspect in the eyes of the more irrational citizens of Madison. He was arrested and confessed to the murder, asking to be spirited away to prison for his own safety. With his guilty admission, he was slapped with a life sentence, and the Dane County sheriff immediately hauled Johnson to the state prison in Waupun. But once out of the city, Johnson recanted, saying that his confession had been a ruse to save himself from a lynching.

A local lawyer, Ole Stolen, took up Johnson's cause and was able to obtain a commutation of the alleged killer's sentence about ten years after the murder. In the interim, a witness came forward to claim that Annie's brother said that their father, Martin, had actually killed the child with a blow to the head and hired someone to dump her body in the lake. The elder Lemberger was arrested for manslaughter, but the charge was dropped because the statute of limitations had run out, and he thus escaped prosecution.

Mark Lemberger, whose father was born five years after the murder, spent several years researching the court records and newspaper reports as the basis for his 1993 book, *Crime of Magnitude: The Murder of Little Annie*. He concluded that Johnson was actually the real killer, but that conjecture was never established in court, and the mystery remains.

Home State Stars

Spencer Tracy, one of the country's most popular actors from the 1940s though the 1970s, was born in Milwaukee on April 5, 1900. He dropped out of high school to enter the navy in World War I and finished his schooling when he was discharged. He attended Marquette Academy with Milwaukee buddy Pat O'Brien, who also would go on to be a major actor. The two award-winning performers remained lifelong friends.

Tracy also went to the Northwestern Military and Naval Academy in Lake Geneva, Wisconsin, and Ripon College in Ripon, Wisconsin. At first he wanted to be a doctor, but he joined the debate team at college and captured the lead in a play, launching his acting career.

Tracy and pal O'Brien went on to attend the American Academy of Dramatic Arts in New York City, with Tracy landing his first Broadway role as a robot in the play *R.U.R*. His stage appearance as a gangster in *The Last Mile* earned the attention of film director John Ford, who cast him as a thug in his movie *Up the River*. Tracy was on his way to film stardom, appearing in numerous movies and being nominated nine times for Academy Awards. He won two consecutive Oscars as best actor, the first for *Captains Courageous* in 1937 and the second for *Boys Town* in 1938. Buddy O'Brien also had a role in Tracy's film *The Last Hurrah* in 1958.

Both men regularly returned to hometown Milwaukee, often dropping in on neighborhood watering holes for

a drink. According to local wags, finding Tracy was a challenge for his agents, or even his paramour of many years, actress Katharine Hepburn, because there were so many bars in the city.

Tracy's last movie was *Guess Who's Coming to Dinner*, made in 1967. The story dealt with his daughter becoming engaged to an African American doctor. His role as the father earned him his final Academy Award nomination. Tracy died on June 10, 1967, in Beverly Hills, California. Famous for his Irish cop and priest roles, O'Brien died on October 15, 1983, with more than one hundred films to his credit.

Another of Wisconsin's premier entertainment personalities, Orson Welles was born in Kenosha, Wisconsin, on May 6, 1915. He was considered one of American filmdom's best directors, known most for his controversial movie, *Citizen Kane*, about a powerful newspaper publisher. Welles was also famous for his radio work, scaring the nation with a rendition of *The War of the Worlds* about Martians attacking Earth. The chilling program was an episode on Welles's *Mercury Theatre on the Air*, performed on October 30, 1938. The Halloween show sent many people fleeing from their homes before they realized it was merely a show.

Welles was one of two sons of inventor Richard Welles. His mother, Beatrice, was an excellent pianist who died when Welles was a child. After her death, he was sent to Chicago to live with family friends, and his guardian, Maurice Bernstein, showed the boy how to play the violin,

paint and perform magic tricks. When only ten years old, Welles fell in love with the theatre after appearing in school plays. As a young man, he even wrote several books about staging Shakespeare's plays.

When he was sixteen, Welles went to Ireland, where he found jobs with several theatre companies, including the famous Gate Theatre in Dublin. He tried to appear older than he was by smoking cigars. When he returned to the United States, he founded the Mercury Theatre Company at age twenty-three. Welles appeared in almost one thousand radio plays, becoming one of the most famous broadcasting voices of the era. He regularly appeared in *The Shadow*, about a detective who could become invisible. Recorded in Welles's sonorous voice, the show's signature line was: "Who knows what evil lurks in the heart of men. The Shadow knows."

In 1939, Welles signed a deal with RKO Pictures in Hollywood, allowing him to write, direct, star in and produce his own films. He died of a heart attack on October 9, 1985, while writing a film script. A bullfighting fan, Welles is buried in Spain, halfway around the world from his Kenosha birthplace.

Tall Tales

Wisconsin has its share of monsters. Some are furry, others scaly. Most are quite toothy and in need of dental care. They live in lakes or caves, prowl the marshlands, hunt in the

forests, scare motorists on rural roads and possibly even tip over sleeping cows. Early Wisconsin writer Louise L. Taylor Hansen wrote that, according to "Algonkin legends, the great serpent always came up the Mississippi River searching for copper, for which it had an enormous appetite."

A creature in Sturgeon Bay supposedly craved more than a diet of metal. Legends along the shore of Lake Superior tell how a "great, hairy serpent" pulled two beautiful young sisters from the beach where they were bathing, and they were never seen again. This part of the lake was noted for its sturgeon, a fish species that predates the dinosaurs. So perhaps the long-ago sighting of an oversized variety of this fish was embellished by adding not just one, but two, lovelies to the legend.

One of the best-known stories focuses on "Rocky," who allegedly lived in the eighty-seven-foot-deep Rock Lake at Lake Mills. Noted Wisconsin scuba diver and underwater researcher Frank Joseph related Rocky's tale, saying that in the summer of 1887, fishermen Edward McKenzie and D.W. Seybert were out on the lake. The fish weren't biting, so they rowed over to the southwest side of the lake, where they noticed what they thought was a tree trunk floating through a marshy area. They rowed closer and saw that it was some sort of animal, with a "fleshy body as long as Ed's boat." The critter had a long, angular neck with a horselike head and "snakelike eyes."

It opened its mouth, exposing what the men reported were serpentlike teeth. They paddled quickly away,

shouting for help. A friend on shore also saw the creature looming over the boat; he ran to his house, got a shotgun and then leaped into his sailboat to come to the rescue. But before he could get to the sighting site, the animal sank with a great splash beneath the water's surface, "leaving the air all around heavy with a most sickening odor," according to other witnesses.

This was not the only time the Rock Lake monster was spotted, according to diver Joseph; reports came out regularly every few years after the McKenzie and Seybert incident. In one instance a decade later, a certain "Mister Hassam" mistook the animal's heavy torso for a tree limb as he paddled his canoe alongside it. About the same time, Fred Seaver, also of Lake Mills, reported that "the animal seized his trolling hook and pulled his boat over half a mile at rushing speed before he [the creature] let go." This was the last time that Rocky or a relative showed its face on Rock Lake, and it eventually became the stuff of around-the-campfire storytelling, says Joseph.

Madison's Lake Mendota also had a serpent lurking in the dark waters off the Wisconsin capital. Reports started about 1917, with both fishermen and university students relating how a giant something-or-other "was out there." It was estimated to be twenty feet long. There may have been some fact in their stories, however, because the lake was long noted as a breeding area for sturgeon.

Wisconsin still grows good-sized "monsters." The largest fish ever taken in the state—a 212.2-pound, 84.2-inch adult

female sturgeon—was speared by Ronald Grishaber on the north end of Lake Winnebago during the 2010 season. He good-naturedly moaned that his regular fishing spot off High Cliff State Park was crowded with other record hopefuls the day after he caught his "big one."

Mister Guitar Man

Internationally known guitar impresario Les Paul was born on June 9, 1916, as Lester William Polfuss in Waukesha, Wisconsin. Always a technical whiz, he built his first radio set at age nine. As a teen, Paul played guitar and harmonica under the nicknames "Rhubarb Red" or "Red Hot Red, the Wizard of Waukesha." So the audience could hear him better when playing at outdoor concerts, he stuck a phonograph needle inside a guitar and hooked it up to his radio, thereby amplifying the sound. When he was thirteen, he constructed a broadcasting station and built his own recording gear.

Paul launched his professional career in a country western band and performed at the Chicago World's Fair in 1939. Staying in the Windy City, he became a disc jockey and performed in jazz clubs. He invented several types of guitars that vibrated longer and better than others being used at the time. Paul performed with numerous famous bands and singers, including the Fred Waring Orchestra, the Andrews Sisters and Bing Crosby.

In 1948, his right arm was crushed in an auto accident. Instead of having it amputated, Paul asked the doctors to set the limb in a position so that he could still play his guitar. He married singer Colleen Summer, whose stage name became Mary Ford. The couple performed together for years, starred on their own television show and wrote sound tracks for a number of popular comedies. Paul was the musical director for the goofy sitcom *Happy Days*. The show featured a group of Milwaukee kids in the 1960s, including Henry Winkler as the famous Fonz and Ron Howard, now a noted film director in his own right.

Paul made twenty-two gold records and earned numerous other music awards, with his guitar styles used by many noted stage personalities. He regularly returned to Waukesha and other Wisconsin venues to perform and raise money for charities. Paul died of pneumonia on August 13, 2009.

The famous musician is memorialized by the Les Paul Performance Center in Waukesha's Cutler Park and the Les Paul Parkway, the Highway 164 bypass ringing Waukesha's east and south sides, marked by signs with a guitar outline.

Big Shot

Progressive Party presidential candidate and former United States president Theodore Roosevelt was saved

from an assassin's bullet by a thick speech that he had tucked into his jacket pocket. While leaving the Hotel Gilpatrick in downtown Milwaukee on October 14, 1912, Roosevelt was shot by New York tavern keeper John Schrank. Schrank had stalked Roosevelt across the country, claiming that "any man looking for a third term ought to be shot." Roosevelt had been the twenty-sixth president from 1901 to 1909.

When Schrank approached Roosevelt, a quick-thinking bystander deflected the gunman's hand and probably saved the ex-president's life. After the incident, the crowd attempted to lynch Schrank, but Roosevelt calmed the mob. He yelled, "Don't hurt the poor creature!" as police hauled Schrank away. Despite a flesh wound, Roosevelt carried on with his campaign speech, with typical fiery oratory that lasted about ninety minutes.

Starting his talk, Roosevelt said:

> *Friends, I shall ask you to be as quiet as possible. I don't know whether you fully understand that I have just been shot; but it takes more than that to kill a Bull Moose. But fortunately I had my manuscript, so you see I was going to make a long speech, and there is a bullet—there is where the bullet went through—and it probably saved me from it going into my heart. The bullet is in me now, so that I cannot make a very long speech, but I will try my best.*

In front of a crowd estimated at about ten thousand listeners, Roosevelt went on to encourage the passage of child labor laws, a minimum wage for women and other social issues considered outlandish by some of his opponents at the time. Following his speech, Roosevelt agreed to go to a hospital, where his wound was bandaged and he received a tetanus shot.

After his brief hospital visit, he boarded the Mayflower, his private campaign train, which was waiting for him at the Northwestern Depot siding at the foot of Wisconsin Avenue.

"Now for a shave," he told his staff.

"But surely, you do not mean that," replied his doctor.

"I certainly do," Roosevelt snorted.

At 1:00 a.m. on October 15, Roosevelt departed Milwaukee for Chicago and a brief hospital stay for observation. He snored so loudly that complaints were made by the other patients on the wing. He was released only days before the election.

However, Roosevelt was defeated by Democrat Woodrow Wilson that November. Schrank was certified as insane and committed to the Central State Hospital in Waupun, where he died in 1943. He never received any visitors or had any mail during his years there.

The auditorium where Roosevelt spoke received a $42 million facelift in 2003 and is now called the Milwaukee Theatre. The Hotel Gilpatrick was shuttered in 1941. The Hyatt now stands at the corner of Kilbourn and North Third Streets, about a block and a half from the hall.

Death on the Island

Jones Island, now the site of the Milwaukee sewage treatment plant, was once home to hundreds of Kashubian fishermen who had immigrated to Wisconsin from Poland. Author Ruth Kriehn, in her book *The Fisherfolk of Jones Island*, related how it was lucky that any children survived the sucking mud, high water, backwash from passing

freighters, overturned boats, storms and other calamities that beset families who lived on that low spit of land.

According to her tales, "the Kriehn family lost three boys to drowning in one year." In January 1894, Carl Kriehn's son Arthur and his brother Frank's son Gustav both died tragically. The six-year-olds were playing on the ice along the mudflats leading to the deeper waters of Lake Michigan, running farther and farther out on the shore. They eventually fell through the thinning ice. Although they were found within a half hour, the cousins had drowned, clinging to each other. In June, Edward, Carl's eight-year-old son, was playing on a Jones Island pier. According to other youngsters, the boy climbed up on a post where several fishing boats were tethered. Apparently, he lost his balance, fell in and drowned. His body was found several days later.

On August 10, 1889, ten-year-old Bertha Kutz and twenty-two-year old Anne Ewig were rowing back to the island from the mainland, where they had been shopping. They waited for a tug to pass, but the larger boat became stuck in the mud and churned its paddles to get free. Thinking that the boat was finally able to proceed, the deckhands waved to the girls that they could get past. However, the tug suddenly started up again when the girls were in the middle of the river. Their little rowboat capsized, throwing the two into the water, where they drowned.

In another sad incident, settlement resident Elizabeth Rotta remembered:

One of the young Choppa boys was walking on the pier one day holding his dog on a leash. Without thinking, the boy threw a stick in the lake. The dog jumped after it, and in a split second, jerked the boy off balance into the lake. He was drowned.

The death list continued with "the little Jeka boy," Paul Budzisz and others.

However, there were just as many rescue stories, including that of Minnie Dambeck, who fell out of a boat in 1904. William Selin, a young man fishing nearby, rowed quickly to the spot where the girl had tumbled into the dark water. "I stuck my arm into the water up to my armpit, searching. Fortunately, I managed to grab her hair. She wasn't breathing anymore. We dragged her to shore as fast as we could," he said. Once ashore, the youngster was placed atop a table, and a passerby "worked on her, squeezing the water out by pushing on her back and stomach." Minnie began to breathe again, so Selin went off to school.

"When I came home, I ran to see how Minnie was. She lived right next door. She was up and well. And was she happy!" Selin recalled. He then went on to relate that many years later, as he was walking along a street in Milwaukee, a "charming young lady" ran up to him, "threw her hands around my neck and kissed me. I was stunned," he said, wondering what had possessed the girl to embrace him.

The answer quickly came when the woman said, "Now I know who you are! My friend here told me you are Bill Selin! You saved my mother's life! Mother told me many times about how you pulled her out of the river. I am Elizabeth, her daughter!"

This Time, It Really Was the Butler

Among the more gruesome crimes committed in Wisconsin was a massacre that occurred in 1914 at the Spring Green estate of noted architect Frank Lloyd Wright. Wright's status did not make him immune from the macabre. The killing of seven members of his household by a servant on August 15 remains one of the state's worst mass murders.

The case captured the front pages around the country, not just for the tragic death toll but also because it involved persons closest to the famed architect. Compounded by an illicit love affair, the story was ripe newspaper fodder.

Wright, with deep Welsh roots, was a native of the rolling hills of west central Wisconsin. He grew up near the village of Spring Green, returning there to build a home after living in Oak Park, Illinois. By then, Wright's reputation was established as one of the country's premier architects. "I turned to this hill in the Valley as my Grandfather before me had turned to America—as a hope and haven," he wrote in his autobiography, adding, "There must be some kind of house that would belong to that hill, as trees and

the ledges of rock did; as Grandfather and Mother had belonged to it in their sense of it all."

But Wright was not interested only in designing his own house. He also felt that he had no choice but to move away from Illinois in order to keep his self-respect because he had abandoned his wife, Catherine (Kitty), and their six children in 1905. The architect had taken up with Martha (Mamah) Borthwick Cheney, a feminist writer and free love advocate. The mother of two youngsters, Cheney was the estranged wife of Edwin Cheney, for whom Wright had designed and built a house in 1903.

To get away from prying reporters, Wright and Cheney spent 1909 in Europe and returned to design his masterpiece building in Wisconsin, calling it *Taliesin*, which, translated from Welsh, is "Shining Brow." He wanted to share the complex of studios and living quarters with Cheney when she finalized her divorce. Retaking her maiden name, Borthwick/Cheney finally left her husband in the summer of 1911 and moved into Taliesin. One reporter from the *Chicago Tribune* wrote that Wright had been seen carrying Borthwick across an icy brook and that she had displayed "a good deal of lingerie of a quality not often on display in that part of Wisconsin."

The two lived happily together at Taliesin for three years, with Borthwick working on her writing, including a translation of Swedish feminist Ellen Key's writings on free love, *The Woman Movement*. Wright spent his time organizing an exhibition of his works to be showcased

in San Francisco, and several of his employees moved to Taliesin to help. Also divorced by then, Wright had landed a commission for Midway Gardens, a center for concerts, dancing and restaurants on Chicago's South Side. Helped there by his son, John, Wright commuted between Wisconsin and Chicago.

During this time, Wright hired thirty-year-old Julian Carlton as a butler and handyman at Taliesin. Carlton's wife, Gertrude, became the cook. Claiming to originally be from Barbados, the Carlton couple was recommended by a client of Wright in Chicago. Yet other workers around the Wright complex in Wisconsin said that Carlton had a temper and was "hot-headed," getting into arguments with the staff. On the other hand, Carlton complained regularly that he was being picked on and harassed by the laborers.

On the day of the murder, Wright, forty-seven, was back in Chicago, and Borthwick was entertaining her children at Taliesin. The household ate lunch as usual that day, served by Carlton. Several workmen were in a smaller room, while Borthwick and her two children were on an enclosed porch with a wide view of the Wisconsin River.

Carlton was given permission from Wright's foreman, William H. (Billy) Weston of Spring Green, to clean the house carpets with gasoline. However, the handyman apparently locked all of the doors, poured the liquid around the house and lighted it.

When those inside tried to escape, Carlton, whom the newspapers described as "the death-dealing maniac,"

hacked them to death with an axe. The first victim was Borthwick, whose skull was almost split in two by the blow. Her eleven-year-old son, John, was killed next. Carlton poured extra gas on their bodies and set off another blaze. Borthwick's nine-year-old daughter, Martha, must have tried to escape because she was later found dead in the courtyard.

Herbert Fritz, a draftsman from Chicago, survived the attack. With his clothes burning, the young man crashed through a window and rolled away. Although he broke his arm, was wrapped in flames and was cut by the shattered glass, Fritz saw Carlton running around the house with the murder weapon. The injured man crawled away to safety as the butler continued his rampage elsewhere.

Fritz was followed through the window by Brodelle. As the second man struggled to get out, Carlton attacked him, burying his hatchet in Brodelle's head. He died later in the day at the home of Andrew Porter, one of Wright's relatives who lived about a half mile away. Weston and the others in the dining room were still trying to get out through the door, which was beside the window. Thomas Brunker was attacked just as he made it outside. A blow smashed his brains, and he lived only for a few hours. David Lindblom, a landscape gardener, was also murdered, as was Weston's badly burned thirteen-year-old son, Ernest. The innocent boy had merely been helping his father that day around the compound.

The elder Weston, who had survived the initial attack, struggled to his feet and tried to flee but was hit again. He

made his way to a nearby house to telephone for help. After calling in the alarm, Weston staggered back to the burning house and attempted to douse the fire with a garden hose. Neighbors aided the Spring Green Fire Department in finally extinguishing the blaze.

Iowa County sheriff John T. Williams and Sauk County undersheriff George Peck organized a posse to hunt for the killer, finding Carlton inside the firebox of Taliesin's unlit furnace. The killer had swallowed muriatic acid, used to clean masonry surfaces, and was in agony. The crowd in front of the ruins wanted to lynch the man, forcing the officers to retreat with their prisoner out a back way. Drawing their guns to hold off the mob, they raced off to the jail in Dodgeville, eighteen miles away.

Upon hearing the news of the murders, Wright rushed back to Madison, joined by Edwin Cheney, ex-husband of his mistress, who happened to be in the same train coach. After viewing the carnage, Cheney returned to Chicago on Sunday with a single casket holding his children's bodies. Their mother was buried in the cemetery of the nearby Unity Chapel, where many of Wright's family were interred.

The murderer died in jail of starvation on Wednesday, October 7. He had almost wasted away, despite initially receiving liberal doses of milk and whiskey in the hope of flushing out his system. He never explained his motive. Wright eventually rebuilt a second Taliesin and lived there on and off until his death in 1959 at age ninety-two.

The story was made into a critically acclaimed opera entitled *Shining Brow*, composed by Daron Aric Hagen. The piece was commissioned by the Madison Opera and premiered in April 1993. *Taliesin: Choruses from Shining Brow*, commissioned in 1995 by the Madison Symphony Orchestra, was a suite based on the original opera. The work premiered in Madison's Oscar Meyer Theatre. Keith Byron Kirk's *As Reaper in Summer Grain* also retold the story of the tragedy, this time through Julian Carlton's eyes.

WILDE ABOUT TOWN

Flamboyant Irish poet and playwright Oscar Wilde visited Milwaukee's Nunnemacher's Grand Opera House to present a lecture on interior design on March 5, 1882. Historian Bobby Tanzilo related how local papers didn't think much of Wilde, only twenty six years old but already well known for his creative talents and out-of-the-ordinary lifestyle. Met at the train station by a horde of reporters, Wilde made an immediate impression on the more staid locals. *Milwaukee Sentinel* headlines blared, "Arrival in Milwaukee of the Distinguished Apostle of the Beautiful," "How the Sunflower-and-Lily Young Man Looked and What He Had to Say" and "Long on Hair and Short on Breeches the Only Striking Peculiarities."

Following Wilde's talk, the *Sentinel*'s reviewer was harsh, to say the least:

Placing one of his white-gloved hands on the little stand and striking an agonizing attitude, rolled his eyes ceilingward and without a formal introduction or any introductory remarks, began his lecture, speaking with a most peculiar accent.

He wore full aesthetic regalia: full dress-coat, double breasted white vest, turn-down collar, pale

blue, almost white, cravat, white gloves, and tight-fitting knee-breeches...He is tall, not very well proportioned, round shouldered, with a head too large for the body, and wears long, wavy black hair. His face is not pleasant to look at, and the great Apostle of "The Beautiful" cannot very well be called a thing of beauty...He speaks with a drawl and his voice is at times coarse and rasping. The lecture was not even interrupted by applause.

The story went on to say, "At the close of the lecture, the speaker made his bow and sought to leave the stage...He failed to find the exit. Turning again he bowed awkwardly to the audience and walked over behind the wings."

Notwithstanding this critique, Wilde, a fan of long walks, strolled through the nearby Italian neighborhood along Brady Street and supposedly said, "If what you want isn't on Brady Street, you probably don't need it," referring to the groceries, bakeries and other retail outlets then in business along the bustling avenue. In a gentler tone, another *Sentinel* reporter indicated that Wilde was "pleased with what he saw in Milwaukee."

In 1999, Wilde's grandson, Merlin Hollander, presented a lecture on his famous forebear in the Pabst Theatre, built in 1895 to replace the Grand, which had been heavily damaged in a fire. Standing on the Pabst stage, Hollander was approximately in the same spot as Wilde had been. Hollander's presentation was featured that year during

Milwaukee's International Arts Festival honoring Ireland. In addition to Hollander's discussion of his noted forebear, Milwaukee hosted Lowell Liebermann's adaptation of Wilde's foreboding *Picture of Dorian Gray*, premiered by the Florentine Opera Company.

Wilde was one among a star-studded panoply of famed entertainers who appeared at the "old" Grand and the "newer" Pabst, including Florenz Ziegfield, Arturo Toscanini, Sergei Rachmaninoff, George M. Cohan, Sir Laurence Olivier, George Bernard Shaw, Noel Coward, Isadora Duncan and Paul Robeson.

The Day the Music Died

Two notable musicians were killed in Wisconsin plane crashes, leaving saddened fans behind to mourn their loss even years after the accidents. A third died leaving a Wisconsin tour.

Singer Otis Redding, twenty-six, died on December 10, 1967, after his Beechcraft H18 went into a spin and crashed in dense fog into Madison's ice-clogged Lake Monona. Four members of his Bar-Kays band were also killed; only trumpeter Ben Cauley, twenty-one, survived. Pieces of the airplane with Redding's name painted on the side are displayed in Cleveland's Rock 'n' Roll Hall of Fame.

On August 27, 1990, blues guitarist Stevie Ray Vaughan was killed when the Bell BHT-206B helicopter in which he was riding crashed into a fog-shrouded hill. The accident was attributed to pilot error; he had failed to maintain adequate altitude before "flying over rising terrain." All five persons aboard the chopper were killed. Vaughan, thirty-five, had just completed performing at the Alpine Valley Music Theatre in East Troy while touring with Eric Clapton. To avoid congested roads, a helicopter was hired to lift the performers to the next venue.

In 2003, *Rolling Stone* magazine ranked Vaughan as number seven in its list of the 100 Greatest Guitarists of All Time and *Classic Rock Magazine* ranked him number three in its 2007 roster of the 100 Wildest Guitar Heroes.

A third noted musician, Buddy Holly, was killed in a plane crash in a cornfield near Clear Lake, Iowa, in 1959, the day after completing a Wisconsin tour. Two friends, Richie Valens and J.P. "the Big Bopper" Richardson, along with pilot Roger Peterson, also died in the accident. Holly had toured the Badger State billed as the Winter Dance Party, rollicking along in a broken-down bus with a faulty heater.

His show in Milwaukee on January 23 was a smash hit, according to the *Milwaukee Sentinel*. "It was crazy, daddy—the goings-on Friday at George Devine's Million Dollar Ballroom," the paper reported. "Nearly 6,000 young people turned out to hear such rock 'n' roll stars as Buddy

Holly and the Crickets, Big Bopper, Dion and the Belmonts and Richie Valens. If you haven't heard them, you haven't lived, man."

The band played the Eagles Ballroom in Kenosha, now supposedly haunted by Holly's ghost, and went on to Eau Claire's Fournier Ballroom. Its next gig was a short stop in Duluth, Minnesota, for a concert attended by a young musician from the state's Iron Range named Robert Zimmerman. He later became much better known as acclaimed singer Bob Dylan.

After their Duluth show, Holly and the others drove down to Appleton, Wisconsin, to appear at the Cinderella Ballroom. However, the bus finally gave out, and the men needed to burn newspapers in the aisle to stay warm before being rescued by the Highway Patrol. Drummer Carl Bunch had to be hospitalized for frostbite because of the weather conditions. As a result, the Appleton matinee was canceled, and the group made its way to an evening performance at the Riverside Ballroom in Green Bay on February 1.

Fed up with his busted bus, Holly chartered the doomed plane from Dwyer's Flying Service to take the group to its Iowa performance at the Surf Ballroom in Clear Lake. The band never made it. At several Wisconsin venues each February, memorial concerts are held to honor Holly.

Darrow for the Defense

Famed lawyer Clarence Darrow defended Oshkosh union leaders in a trial following a strike that stretched over the spring and summer of 1898. More than two thousand woodworkers had walked off their jobs over wage cuts and issues of job security at the city's seven woodworking firms. The Wisconsin National Guard was called in with Gatling guns and cavalry to defend the plants after one sixteen-year-old striker was clubbed to death and thousands turned out for his funeral. Management asserted that the Oshkosh strike was a conspiracy, a tactic used across the country to break up unions and jail its leaders. Throughout this era, companies could claim that workers illegally planned, or "conspired," to hold a strike and thereby keep their plants open.

Darrow's final speech to the jury lasted more than seven hours and was delivered without notes. His stirring words resonated within the courtroom:

> *I take it that in a free country, in a country where George M. Paine* [president of the Paine Lumber Company in Oshkosh] *does not rule supreme, every person has the right to lay down the tools of his trade if he shall choose. Not only that, but in a free country, where liberty of speech is guaranteed, every man has a right to go to his fellow man and say, "We are out on strike. We are in a great battle for liberty.*

We are waging war for our fellow men. For God's sake, come with us and help." Has it come to that point in America, under the guarantee of the freedom of speech and under the Constitution, that a free man cannot go to his neighbor and implore him not to work? If a jury or a court should write a verdict like that it would be the death knell to human liberty.

In his last comments, Darrow implored the jury to "render a verdict in this case which will be a milestone in the history of the world, and an inspiration and hope to the dumb, despairing millions whose fate is in your hands." After fifty-five minutes, the jury returned a not-guilty verdict, and the strike leaders were freed.

Grave-Robbing Guy

In 1914, the same year as the Taliesin murders of architect Frank Lloyd Wright's mistress, her family and several of his staff, a woman named Augusta Gein moved her family to the village of Plainfield. She hoped to save her two sons from what she considered the low morals of La Crosse, where they had previously lived. Supposedly safe on the new family farm, Mrs. Gein expected her youngest son, Eddie, to turn out differently than the depraved residents of their former community. He did, but not in the way his mother expected.

As an adult robbing graves in the 1950s, Gein made lampshades and other household items out of human skin, which he stripped from cadavers. "Ed Gein will get you, if you don't behave," was a common refrain of other mothers in those days.

Gein's story is more than just the recounting of murder; it is one of unspeakable horrors so terrible that they inspired uncounted articles, dozens of books and many movies. The latter include Alfred Hitchcock's trend-setting *Psycho* (1960); the ultimate fright film, *The Silence of the Lambs* (1991); and the classic death-by-machinery romp, *The Texas Chainsaw Massacre* (1974).

But Edward Theodore Gein was not technically a serial killer because he "only" murdered twice. According to police, it takes three murders to qualify for that unholy honor. What catapulted Gein into the horror hall of fame was the fact that he dug up at least nine graves,

skinned the corpses and dangled body parts around his dilapidated house.

Each "victim" was a recently deceased middle-aged woman, many of whom Gein had known in his central Wisconsin hometown of Plainfield. He avidly read obituaries, went to the grave sites, unearthed the bodies and took whatever pieces he wanted. Gein claimed that his aberration was done in what he called a "daze." During his interrogation about using skulls for bowls, Gein asked the police for something to eat. He was given a piece of apple pie with a slice of cheddar cheese, but he complained that the cheese was dry. So much for Wisconsin's sterling reputation as the premier Cheese State.

The story was perfect for the press, but it took several days to gather momentum. After Gein's arrest on November 16, 1957, the early edition of the *Milwaukee Journal* headlined, "Missing From Store, Widow Found Dead." The *Milwaukee Sentinel*'s six-star final edition only had "Woman Store Owner Dead; Suspect Held" for its front-page story. But the next day, as the details unfolded, headlines screamed, "Murder 'Factory' on Farm! Find Remains of 5 Slain Women; Plainfield Widow Cut Up, Hanged by Heels in Shed."

Dick Leonard, retired editor of the *Milwaukee Journal*, recalled that on Sunday, November 17, 1957, he was the only staffer in the newsroom, other than a sportswriter. An Associated Press reporter burst into the newsroom, yelling that a killer had been apprehended and that there were bizarre items uncovered in the suspect's home.

"I finished what I was doing, then got in my car and drove up there as fast as I could. I knew it would be a good story," said Leonard. But it was getting dark, and he wondered if he could find the murder site. "I finally made it but couldn't get into the house because it had been secured by that time," he said. Leonard subsequently filed his front-page story from a motel room later that night, with the resulting headline: "Plainfield Farmer Admits Grisly Act."

Leonard covered the Gein story for several days and attended Gein's arraignment. "I went into the courtroom and sat on one of the long wooden benches. They brought in Gein and put him down right next to me. He was nervous, not too bright. Gein turned to me and grabbed my hand, asking, 'What are they going to do to me. What are they going to do?'" Leonard said. The surprised reporter tried to calm him, assuring him that everything would be all right.

"That was a historic moment for me, my hand being held by a killer," recalled Leonard, who bemoaned the fact that he never had the chance to ask Gein any direct questions. The court proceedings started, and the accused killer was whisked away.

Sightseers by the hundreds drove around Plainfield after the story came out, hoping to see Gein's boarded-up home and the murder scenes. Sheriff's deputies from several counties were posted at Gein's farm to keep away the curious, including University of Wisconsin–Madison fraternity boys eager to hold beer parties on the man's porch.

On Friday, November 22, Gein appeared before Circuit Judge Herbert A. Bunde, who signed an order committing the admitted grave robber to Central State Hospital for the Criminally Insane at Waupun for mental testing. The day before, he had entered a plea of not guilty by reason of insanity. A board of specialists reviewed all of the data on December 19, ending the session by stating, "This man, in the opinion of the staff, is legally insane and not competent to stand trial at this time." After reading the medical team's report, Judge Bunde agreed to hold Gein at Central State indefinitely because he agreed that Gein was not mentally able to stand trial.

On the night of March 20, 1958, prior to an auction of Gein's farm implements and household items, his house mysteriously burned down. Arson was suspected, but nothing was ever proven. On March 23, more than twenty thousand gawkers showed up for a pre-auction site inspection, looking at the cordoned-off, smoldering ruins of the building and poking around a barn and sheds until dark. More than two thousand came to the auction itself, purchasing rusted farm equipment, an old stove, a keg of nails and other household items not connected to the murders at bargain prices.

The farmland itself went for $3,883, going to a local developer who eventually tore down Gein's remaining outbuildings and planted sixty thousand trees over the site. Fourteen persons bid on Gein's 1949 maroon Ford, the winner being Bunny Gibbons of Rockford, Illinois, who

then took the vehicle on the carnival circuit. The auto, which sold for $760, had been used by Gein to haul victim Bernice Worden's body to his home, where he carved it up. A 1938 Chevrolet pickup, which Gein used to haul his second victim, Marie Hogan, went for $215 to Chet's Auto Wreckers of Highland and began its next undistinguished career hauling scrap iron.

Eleven years later, Gein was judged sane enough to head back to the courtroom to finally stand trial in Worden's death. He was convicted and sent back to Central State Hospital, resuming his duties as a mason, medical center aide and carpenter's helper, making $1.50 a week. While still in jail, Gein died of heart failure on July 26, 1984.

Play Ball!

Ball playing is nothing new to Wisconsinites; lacrosse was a popular sport among sports-loving Native Americans long before white settlement. Some of these games lasted for days, often resulting in broken bones and even death. In 1667, French explorer Nicholas Perrot watched an abbreviated match played at a Miami village alongside Green Bay:

> *More than two thousand person assembled in a great plain, each with his racket; and a wooden ball, as large as a tennis-ball, was thrown into the air. Then all*

that could be seen was [sic] *the flourishes and motion through the air of all those rackets, which made a noise like that of weapons which is* [sic] *heard in a battle. Half of all those savages endeavored to send the ball in the direction of northwest, the length of the plain, and the others tried to make it go for the southeast; the strike, which lasted half an hour, was doubtful.*

Centuries later, baseball's American League was born in Milwaukee on March 5, 1900, when a group of the game's enthusiasts met to incorporate the organization. Meeting in the Republic Hotel's Room 185 were Milwaukee attorney Henry Killea; his brother, Matt; Connie Mack; Bryon (Ban) Johnson; and Charles Comiskey. At the time, Johnson was president of the minor Western League and was upset when the National League dropped several teams in a contraction move that shocked baseball fans. When this occurred, Johnson figured it was time to make a move and challenge the National League with an organization of his own.

At the Milwaukee brainstorming confab, Comiskey's Chicago White Stockings (later the White Sox) were incorporated and joined the new American League. After the 1900 season as a minor league, the division reorganized, with teams in Baltimore, Boston, Philadelphia and Washington, D.C. The site of the Republic Hotel is now a parking lot for the *Milwaukee Journal Sentinel*. For years, a plaque noting the league's founding was mounted on the

fencing at the corner of North Old World Third Street and Kilbourn Avenue.

When the clutch of men started the league, they probably never dreamed that eventually women would also be making their names on the baseball diamond.

Marquette University graduate Dorothy (Kammie) Kamenshek has long been considered one of the best female athletes in the country. Born December 21, 1925, her career became the basis for the 1992 movie *A League of Their Own*. Growing up in Cincinnati, her first love was softball. Playing in an industrial league from age twelve, the seventeen-year-old was spotted by a pro scout and invited to show her skills in Chicago's Wrigley Field.

Demonstrating her ball-playing prowess, she was one of sixty young women selected in 1943 to play in the All-American Girls Baseball League, making it onto the Rockford Peaches team. The league was prim and proper, with the players wearing short skirts and attendance required at evening "charm school." No drinking was allowed; cursing, smoking and unchaperoned dates were also outlawed. The players earned fifty dollars a week.

Kamenshek started in the outfield and was eventually moved to first base, where she played so well that male players admired her speed and ball-catching abilities. In 3,736 times at bat, the lefty only struck out 81 times. Her lifetime batting average was .292; she earned cheers whenever she stole one of her 652 career bases. Defensively, she held records for double plays and

putouts, being named to all-star teams seven out of her ten years of play.

Kamenshek always dreamed of attending college, but her salary in 1950 was only $100 a week, not enough for tuition. Her fans wouldn't let her down. They held a "Kammie Night" in Rockford, with more than thirty-eight hundred persons donating almost $1,000 to a school fund, along with enough other gifts that it took a truck to move the donations.

Still needing to earn more tuition money, even while requiring a back brace because of an injury, Kamenshek managed to slam in an average of .345 and steal sixty-three bases in 1951, her last season. Seizing her chance to go to school, Kamenshek first attended the University of Cincinnati but debated what to select for her career path. The young woman decided on physical therapy, but Cincinnati required her to take chemistry, and Marquette only demanded a physics requirement. "I wasn't any good at chemistry, so I went to Marquette," she later recalled of her time in Wisconsin.

Kamenshek put the same enthusiasm into her classes as she did on the ball field, getting up at 4:00 a.m. to study after working at a bakery until midnight every day. She kept her playing abilities a secret at Marquette, and few knew of her athletic career. Graduating in 1958, Kamenshek settled in California, becoming head of the Los Angeles Crippled Children's Department. She retired in 1980. At eighty-three, she suffered a stroke, limiting

her ability to attend reunions of the women's league, but even in 2010, she stays in touch with her old teammates via telephone.

"It gave a lot of us the courage to go on to professional careers at a time when women didn't do things like that," she said of her playing in the book *Women at Play: The Story of Women in Baseball*. In 1999, *Sports Illustrated for Women* named Kamenshek one of the one hundred greatest female athletes of the twentieth century.

Hot Times

Fires were a constant threat in early Wisconsin, with an October 8, 1871 fire around the lumber town of Peshtigo causing the most deaths by a single blaze in United States history. The final tally was never known, but it is estimated that between 1,200 and 2,400 victims died in the tragedy. The firestorm covered twenty-four hundred square miles, or 1.5 million acres, in Wisconsin and upper Michigan; it was caused by a drought, high temperatures, slash-and-burn methods of clearing land for farming and sparks from passing locomotives. The Wisconsin fire, however, was overshadowed by the more notorious Great Chicago Fire, which occurred on the same day, in which 250 persons died.

A report to the Wisconsin state legislature in 1873 described the horror in chilling detail:

Fully three months of hard and laborious work have been sent by Col. J.H. Leavenworth in making up a list of those burned; whole neighborhoods having been swept away without any warning, or leaving any trace, or record to tell the tale. It has been a difficult task to collect the number and names of families who have wholly or in part perished, although no pains have been spared to search out the survivors and make the records as nearly correct as possible.

The list can be depended upon as far as it goes, but it is well known that the numbers of people were burned, particularly in the village of Peshtigo, whose names have never been ascertained, and probably never will be, as many of these were transient persons at work in the extensive manufactories, and all fled before the horrible tempest of fire, many of them caught in its terrible embrace with no record of their fate except their charred and blackened bones.

The people of Peshtigo can all tell of acquaintances they had before the fire of whom they lost all knowledge since, and that many perished in the company's boarding house and the catholic and presbyterian churches, of whom not a vestige remains, there seems to be no reasonable doubt; for the very sands in the street were vitrified, and metals were melted in localities that seem impossible.

One mass grave at the Peshtigo Fire Cemetery holds the remains of 350 persons. Annually, on October 8, the

Peshtigo Historical Society marks the anniversary of the tragedy with a special candlelight service.

Another of the state's noteworthy blazes was the conflagration in Delavan that destroyed part of what was called the Deaf and Dumb Institute. The nationally recognized facility devoted to the care of hard-of-hearing youngsters is now called the Wisconsin School for the Deaf. In the aftermath of the fire on September 16, 1879, newspapers across the country picked up on the story, focusing on the escape of the staff and their young charges. The fire started under the central dome of the institution's main building about 8:00 a.m. and spread quickly to destroy the structure's eastern wing.

A Chicago publication described the incident with much greater flair than many other newspapers. The *Inter Ocean* reported that

> *the beautiful buildings of the State Institution for the Deaf and Dumb are in ruins. The buildings and the wings, together with the engine house, kitchen, and laundry buildings were burned this morning. The fire was discovered in the cupola of the main building about 8:30 o'clock. It spread rapidly, and soon enveloped the roof and run* [sic] *down the winding stairs to the first floor, thus setting fire to all parts of the main building.*
>
> *The fire company come* [sic] *out with their Babcock engine and worked like herots* [sic], *but the fire was so high that the hose would not reach it. The building*

was full of children. There were 147 in attendance yesterday, besides the employees. They were all gotten out of the building safe, and none were hurt. The sight of the poor unfortunates as they ran in terror from the building, crying in their painful way and wringing their hands, was enough to move the stoutest heart. They have been kindly cared for by the warm-hearted citizens, and are all safely housed now.

The heat was intense at times, and the roaring and leaping of the flames terrible. The burning buildings were seen for miles, and people came from long distances to see the fire.

The Trustees and Governor were promptly notified, and were on the ground as soon as possible. Governor Smith arrived at 3:40 p.m., and is giving his personal attention to the work of carrying forward the interests of the State. The Trustees had a meeting on the institute grounds this afternoon and have determined to go on with the school. A number of large residences on Asylum Hill will be thrown open to accommodate the pupils, and the shops and various outhouses on the institute grounds utilized for school purposes. The walls of the west wing are not much injured, and can be used in a new building. The loss is $110,000; no insurance.

The horrific Newhall House blaze in downtown Milwaukee on January 10, 1883, was another fire with

high loss of life. Seventy-three persons perished, including forty-three who were so severely burned that they were never identified. The victims were honored by a funeral mass at St. John's Cathedral and a Protestant service at the Exposition Hall. A number of dead were maids who lived on the sixth floor of the hotel, many of whom tried to escape the flames by jumping into nets and canvases held by firemen below. However, the nets were so old and rotted that they broke apart when panicked individuals landed on them.

Among those rescued were Mr. and Mrs. Charles Stratton. The twenty-five-inch-tall Stratton was better known as General Tom Thumb of P.T. Barnum show business fame. The couple was married on February 10, 1863, with President Abraham Lincoln hosting a honeymoon reception in the White House for the famous pair. The two were saved when a brawny fireman snatched them up and carried them down a ladder to safety.

Others were not so fortunate, as the *New York Times* of January 11, 1883, reported:

> *Every window of the large six-story structure was filled with struggling guests, frantically and piteous… About a dozen persons jumped from the Michigan-street front. Each leap meant death or shattered limbs, and not less than four unfortunates at one time lay upon the icy sidewalk in front of the Chamber of Commerce clad only in night clothes… To the poor waiter girls, all*

lodged in the sixth story and the attic, the saddest lot had fallen. Of 60 young girls only 11 were heard from as alive this evening.

The central Wisconsin village of Westfeld was ready in case fires broke out in the community. In 1905, the village established a volunteer fire department headed by Chief W.J. McWilliams. Horses were used to pull the single fire engine, and firefighters were paid one dollar for each blaze they helped put out. In 1907, a special election gave approval to purchase a $1,500 gasoline-powered fire engine. However, these precautions came to naught in 1917, when Westfield's original firehouse burned down. The structure was rebuilt for $2,500.

Bloody Third Ward

Milwaukee's Irish neighborhood along the Milwaukee River easily earned its nickname as the Bloody Third Ward in the 1800s. On September 6, 1861, black and white workmen were caught up in a street fight in which an Irishman, Darbey Carney, was stabbed to death and another wounded. The police arrested two African American laborers, James Shelton and Marshall Clark, for the killing. A lynch mob formed and attacked the front door of the city jail with an eighteen-foot-long timber ram. In the mêlée, police chief William Beck and a couple of his

patrolmen were tossed into the gutter. Clark was dragged from his cell and beaten senseless, while Shelton was able to escape through an open door. He scaled a high fence and made his getaway. The unfortunate Clark, however, was hauled to the corner of Water and Buffalo Streets and hanged from the top of a pile driver being used on a nearby construction project.

Shelton was soon recaptured and tried. During his trial, two military units were posted at the courthouse to prevent another riot. A jury found Shelton not guilty, with the verdict appearing to be based on the premise that Clark had already been hanged for the offense and executing another person would be unjust. After the trial, Shelton was smuggled out of Milwaukee before another mob could gather. The once-lauded Chief Beck was blamed for not doing more to protect the inmates, and he resigned in October.

Politician's Graveyard

Wisconsin governor Louis B. Harvey died in a freak accident, drowning on April 19, 1862, after inspecting Wisconsin troops after the Battle of Shiloh. The popular politician apparently was crossing over from one boat to another near Pittsburg Landing on the Tennessee River when he slipped and fell into the muddy water. His body still had not been found when the first dispatches were sent out.

By April 21, newspapers were up to speed on the tragedy, reporting:

> *The Executive Department received the startling announcement of the death of Governor Louis P. Harvey, drowned at Savannah, Tennessee, on Saturday night. The State offices were closed for the day, and flags lowered at half-mast.*
>
> *Gov. Harvey was a native of Connecticut, 42 years of age, was a member of the Convention which framed the Constitution of the State, and for several years a leading member of the State Senate. At the time of his death he was engaged in the humane object of ministering to the wounded at Pittsburgh [sic] Landing, having taken with him an immense amount of hospital stores, donated at his suggestion by the cities of Milwaukee, Madison, and Janesville. His successor is Lieut. Gov. Edward Salomon, of Milwaukee.*

Harvey was noted for his compassion and concern for the state's troops. Shortly before his death, he wrote a report, stating, "It would have moved a heart of stone to witness the interviews between the Governor and our wounded heroes. There was something more than formality about these visits, and the men knew it by sure instinct."

His wife, Cordelia Perrine Harvey, was a nurse who continued to inspect military hospitals after her husband's death and became a major reformer in the field of military

medicine. Nicknamed the "Wisconsin Angel," her lobbying of President Lincoln persuaded him to establish three hospitals for wounded soldiers in Wisconsin. She also set up a home for Wisconsin youngsters who lost their families during the war.

Cordelia grew up on a farm in the Kenosha area and married Harvey, a schoolteacher and shopkeeper who became Wisconsin's secretary of state in 1859 and was elected governor in 1861. Although she remarried in 1876, she and her first husband are buried together at Madison's Forest Hill Cemetery.

Edward Salomon, the governor who replaced Harvey, was born in Prussia, coming to Wisconsin in 1849. He was admitted to the Wisconsin bar and became a member of the University of Wisconsin Board of Regents. Thrust in the spotlight upon Harvey's death, the *Milwaukee Sentinel* wrote that "Mr. Salomon is a German by birth. He has, however, resided most of his life in this country, is a thorough master of our language, and as a successful and accomplished lawyer is fully conversant with American Institutions and modes of business." After serving as governor until 1864, Saloman later moved to New York City, where he was Prussian consul. After his German-born wife became ill, the couple returned to Germany, where Saloman died in 1909.

Salomon was not the only politician in his family. His cousin, Brigadier General Edward Selig Salomon, was appointed governor of the Washington Territory by President U.S. Grant in 1869.

Prayers for All

Wisconsin's frontier was a mishmash of religious faiths, as settlers from dozens of ethnic heritages flocked to the state. It was often challenging for those of different religions when no church or trained clergyman was available to serve their respective religious needs. Lutherans, Catholics, Free-Will Baptists, Methodists and other congregations regularly argued about who was to make it to heaven first. Sometimes individuals needing a prayer made do by participating in a service with another faith. One Bavarian Lutheran told how he attended a German Methodist meeting:

> *At the conclusion of the hymn, we are asked to pray and all fall on their knees, but not forward for they turn around on the backless bench and then throw themselves down or lie on it. And the preacher (anybody can be a preacher, for they had no clergyman educated at a seminary) says a prayer. But not out of a prayerbook, for they don't consider that worth anything. (I with all my books am doomed to hell). The prayer must come spontaneously from the heart, and they say that as soon as one has prayed fervidly and become penitent, he is saved.*

The Deadliest Blast

In September 1917, former Catholic priest turned Methodist evangelist August Giuliani was actively preaching in Milwaukee. He had set his sights on converting the Catholics of the largely Sicilian Third Ward and the smaller northern Italian enclave of Bay View. He also felt that it was his patriotic duty to encourage young men to enlist in the military since the United States had just entered World War I.

Giuliani was usually met with resistance from the area's numerous antiwar activists, who knew what war was like firsthand because they were recent European immigrants. Because of unruly crowds, Giuliani asked for police protection during his curbside services. According to Giuliani, the dissenters threatened him, saying, "You must not come down here any more. We have a lake here and we throw you down in the lake and we cut your head off."

At one prayer session on Sunday, September 9, 1917, a crowd gathered to jeer at the preacher and his supporters. Several patrolmen were on hand to keep order and confronted the protesters with drawn weapons. Shots were exchanged, resulting in the deaths of two protesters and the injuring of two others. One of the victims was shot in the back. Two officers were also slightly wounded. In explaining his actions, one policeman said, "I seen guns coming out of their pockets and didn't wait a moment

and shots were fired and I drew my gun and fired into the crowd."

Two months after this incident, a bomb was found at Giuliani's Third Ward church. The device, carried to the central police station by one of Giuliani's parishioners, exploded and killed nine policemen and a civilian. The thunderous blast marked the largest loss of police life in a single incident in the United States, until another nine officers were killed in the Oklahoma City bombing on April 19, 1995, and dozens on September 11, 2001, in New York. The incident was linked to the Bay View fracas by the clergyman, city authorities and the city's rabidly anti-anarchist *Milwaukee Sentinel* and other newspapers.

In lurid detail, newspaper reports described the glass, plastering, shredded clothing, shattered torsos, arms, legs and burned papers that littered the floor. One story told how

> *a cap from an officer's head hung on a broken bit of glass in a side window. Through the gaping windows, the faint light of a street lamp flickered on the scene... from the ceiling swung loosened planks and the two blackened chandeliers.*

Several dozen suspects were subsequently arrested in a quick sweep through Milwaukee's immigrant neighborhoods, most being well-known political activists. The usual suspects, so to speak. Barely a week later,

court proceedings began for several Italians accused of participating in the Guiliani shooting incident. It wasn't long before nationally recognized figures such as attorney Clarence Darrow and radical activist Emma Goldman became involved, questioning whether the defendants were receiving a fair trial.

At 8:20 p.m. on Thursday, December 20, after deliberating seventeen minutes, a jury found eleven defendants in the Guiliani case guilty of conspiracy to "assault with the intent to kill and murder." Each was sentenced to twenty-five years at the state prison in Waupun. In a strange legal twist, even Areno Nardini, the infant son of convicted conspirators Pasquale and Mary Nardini, was sent to a detention home in Wauwatosa. A few days later, the judge sentenced the baby boy to spend the next twenty-five years in an orphanage, ignoring pleas from other family members who offered to care for him.

However, the police never solved the bombing case, despite continual assertions that the culprits were anarchists.

As an interesting side note to this anarchist incident, Joseph E. Uihlein, president and CEO of the Jos. Schlitz Brewing Company at the time, was always a fan of the workingman. As a youngster, he recalled watching anarchists parading through the city streets, waving their red banners and shouting slogans. Uihlein later said that if corporations did not treat their laborers and staff well, anarchy would be the result. He even testified before the

Wisconsin legislature that a tax on corporations should be levied to help pay for workers' health insurance.

After Uihlein retired from day-to-day management of the brewery, he remained on the brewery board. Yet he gave away much of his fortune to his children and charitable causes. Many of his relatives didn't understand his actions, calling him a communist. Uihlein fired back, saying that he no was more a communist than the pope.

Another twist of history focused on Uihlein's mansion in Milwaukee. The magnificent lakefront property was designed by the dynamic duo of Charles Kirschoff and Thomas Rose, Milwaukee's most important architectural firm between 1897 and 1973. A wing of the Uihlein home was called the "playhouse" because the family's children and their cousins held their Christmas parties there. This part of the sprawling old home was topped by a whimsical bear statue high atop the fireplace chimney.

The home was eventually donated to the University of Wisconsin–Milwaukee. In the 1980s, the university gave up title to the property, and the home was subdivided into four condo units by Uihlein's architect grandson, David Uihlein Jr. The playhouse unit went through a succession of owners and was eventually purchased by filmmaker Maxine Wishner and noted actor Dan Mooney. Adding to the turns in this tale, Mooney portrayed Luigi Galleani, a leading Italian anarchist in pre–World War I America, in the movie *No God, No Master*. While filming in Milwaukee in 2009, the director wanted to use the gated entrance at

the old Uihlein house as a backdrop in depicting John D. Rockefeller's estate. However, for various reasons, another site was utilized.

Much of the film was shot along Brady Street on Milwaukee's East Side and in the Third Ward, where Reverend Guiliani's missionary church had been located generations earlier. In addition, scenes of anarchist rallies were filmed in an old warehouse at the former Pabst Brewery, one of Schlitz's major competitors. The empty building was available, awaiting development into an office/condo/entertainment complex by a grandnephew of Joseph Uihlein.

How Dry I Am

Wisconsin ratified the national Prohibition amendment to the constitution by a vote of nineteen to eleven in the state senate on January 16, 1919, and fifty-eight to thirty-five in the house on the following day. With these votes, Wisconsin became the thirty-ninth state to go dry. The *Anti-Saloon League Year Book* of 1919 rattled off statistics that demonstrated the impact of the ruling and gave some history of the movement in the state:

> ** When wartime Prohibition becomes operative on July 1, 1919, 9,636 saloons and 136 breweries in the state will be closed.*

> ** The city of Milwaukee has over 2,000 saloons, a larger number in proportion to the population than are to be found in any other large city in the United States.*
> ** In the spring elections of 1915, 35 cities and villages went dry for the first time while only three small villages changed from no-license to license. It is estimated that during 1914 and 1915, the saloon was voted out of territory inhabited by 60,000 people and as a result 400 saloons were compelled to close.*
> ** Thirty-one incorporated cities and villages, including Superior, the second city in the state, voted out the saloon in 1916. Four of the normal school cities of the state—Superior, River Falls, Menominie and Plattville—voted out the saloon. In these four cities, 2,200 young people were attending school. A net gain of 85,000 people in dry territory was made at the spring elections in 1916 and 400 saloons closed their doors in July of that year.*

Despite their glee with the "demise of drink," the Anti-Saloon Leaguers did not count on wily Wisconsinites still appreciating their malted beverages and finding ingenious ways around the law. Minnie Edler, a scrubwoman at the Cream City Brewery from the 1880s until her death in 1933, secreted away a beer-making recipe given to her by the firm's brew master Gustav Hanke. The instructions made for perfect homemade brew during the long, dry days of Prohibition:

Put 3 oz. of hops in 2 gallons of water and boil for an hour and a half. Strain through a cotton sack and add to the liquid 1½ pounds of granulated sugar, 1 quart of malt extract and 3 gallons of boiling water. Boil the mixture for 25 minutes and let it stand in an earthenware crock or wooden tub until it is lukewarm. Dissolve one cake of yeast in a cupful of lukewarm water and add to the liquid in the crock. Set the mixture in a warm place and allow to ferment for 60 to 70 days. Skim off foam twice a day.

Filter through fibre and bottle. Cork tightly and let it stand in a warm room for 2 days. Then remove it to a cool place and keep it there for another week before using. If the liquid foams too much when the bottle is opened, it was bottled too soon. If too flat, it was allowed to stand too long before bottling. Omit fermentation in dry territory.

John C. Eigel, in his article "Surviving Prohibition in Milwaukee" for the Wisconsin Historical Society's *Historical Messenger*, related that Minnie's oldest son owned a cartage company and often hauled beer in his trucks. When his eldest daughter was to be married, the man secured an entire barrel of beer from one of his sources and hauled it from the town of Wauwatosa to his house at Fourth Street and Garfield Avenue. The wedding reception was held in the garage, with the beer flowing liberally.

Mr. Nelson Comes to Wisconsin

It wasn't always easy reaching Wisconsin in the old days before trains and planes. The following relates the journey of young Andrew Magnus Nelson from his home in Norway to Wisconsin. Nelson went on to become a respected businessman and land developer in Portage County and Arkansas. The full text can be found in the Stevens Point Area Genealogical Society archives.

> *When the Nelson family set sail from Port Porsgrund, Norway, April 20, 1857, the seas were comparatively safe even for a slow-going sailing vessel, and their friends at home had no fears as to their safe arrival, after thirty-eight days on the water, in their port of destination, the Harbor of Quebec. This little party was made up of Andrew Magnus Nelson, then a youth of fourteen years and now one of Portage County's capitalists, and his father and brother, James J. Nelson.*
>
> *Andrew Magnus Nelson was born April 14, 1843, near Porsgrund, Norway. His parents were Nels A. and Ingeborg (Toldnes) Nelson. His mother died when he was three years old. He had a brother, Isaac N., who was born in Norway in 1827, became a sailor and in 1849 immigrated to Wisconsin and became a farmer near Scandanavia [sic] in Waupaca County, where he died at the age of eighty-eight years.*

The Nelsons landed safely at Quebec after a voyage of about five weeks, and there took a boat to Montreal and Toronto, from there went by rail to Detroit and from there to Chicago, reaching that place June 10, 1857. They were bound for Scandanavia to join their kindred in Waupaca County, Wisconsin, and from Chicago they yet had a long journey before they ended their travels.

The contrast between transportation facilities in the old days and now is interesting. By boat from Chicago they reached Milwaukee, where they again took a railroad train, on the newly built Northwestern, to Fond du Lac, which was then the terminus, and then reached Oshkosh by boat and on another boat reached North Port on June 13, 1857, when they found themselves within thirty miles of Scandanavia [sic], Waupaca County, which distance they covered on foot.

Egg-cetera

Chickens on Wisconsin farms from January through November 1941 produced 1,791,000,000 eggs. If loaded simultaneously in twelve thousand refrigerator cars, the eggs would have made up a train ninety-four miles long.

Monumental Dedication

The towering Soldiers and Sailors Monument in Kenosha was dedicated on a bright, cloudless May 30, 1900, before a crowd estimated at upward of thirty thousand persons. That was more than twice the population of the southeastern Wisconsin city at the time; many visitors came by train from Chicago and Milwaukee for the event. Part of the celebration included tours of Kenosha's new Gilbert Simmons Library and the USS *Michigan*, the U.S. Navy's first ironclad warship, launched in 1844. The memorial's sixty-foot-high Corinthian column honoring the area's servicemen and women was located at the north end of the Library Park along Fifty-ninth Place in downtown Kenosha.

Both the library and monument were designed by the internationally famous architect Daniel H. Burnham, who also directed the plans for many of the buildings at the 1893 Columbian Exposition in Chicago.

About noon on the festive day, drummers sounded an assembly call to gather all of the dignitaries at the column, with a march-by of the Fred S. Lovell Post of the Grand Army of the Republic. Speakers included Captain George Hale, Lovell Post commander; attorney Peter Fisher Sr.; Reverend Samuel Fellows, a chaplain for Wisconsin troops in the Civil War; and other notables.

Atop the column, the largest single piece of granite ever brought into the state, was a carving of *Winged Victory*

made by Italian sculptor Decco. As the *Kenosha Evening News* reported:

> *At the close of the speech of Mr. Fisher, Miss Elizabeth Simmons was escorted to the base of the monument by Col. E.G. Eimme, a one-armed veteran…As the flags covering the monument parted to the right and left, the bands began to play the "Star-Spangled Banner," while the warship and revenue cutters fired a mighty salute in honor of the unveiling.*

Kenosha County had 1,367 men in service during the Civil War, with seventy-two casualties. By the end of the war, it was estimated that almost each of the fourteen thousand county residents had a relative, friend or neighbor who had died in the conflict.

Buggy Busting

Sometimes, simply riding home in the good old days of the horse and buggy could be just as life threatening as boarding a train. Well-known Boscobel farmer Albert Wheeler was fatally injured in a runaway when he was thrown from his wagon on a nighttime ride back to the family home. His wife and their fourteen-year-old child, both unidentified in news stories, were seriously hurt in the accident, which occurred on September 10, 1895. Newspaper accounts

reported that his team "took fright and ran away," causing their wagon to flip over on the uneven roadway.

Eddie Olson, the thirteen-year-old son of Mr. and Mrs. Sam Olson of the town of Edson, near Chippewa Falls, was fatally injured on September 9, 1895, "in a manner which his folks are unable to account for," according to the *Centralia Enterprise and Tribune*. A woman passerby found young Olson lying along the road "with an ugly gash in the head from which the blood and brains were oozing." His horse, on which he had ridden from home, was said to have been standing over the prostrate form "like a sentinel on guard." The boy died soon after the accident.

Scarface Al's Woodsy Getaway

In the late 1920s, Chicagoland gangster Al Capone purchased property near Couderary, seeking a remote site within a two-day jaunt of his Windy City turf. As a hardworking "businessman," Capone needed a retreat for rest and relaxation.

He subsequently built a stone house with eighteen-inch thick walls backed up by a lookout tower, gates and related security systems. A bunkhouse was constructed for his men. At the time, the fortlike home cost $250,000 to build. Indulging his love of fishing, the lakefront retreat had an eleven-hundred-foot frontage on Chippewa

Flowage, with a pier from which the mobster could hit golf balls far out into the water. A generator provided power for the complex.

In 1959, local entrepreneur E.N. Houston purchased the property from Capone's estate and turned the place into a restaurant and museum, promoting it as the Hideout. Some of the original furniture remained in the main building while it was a resort. Visitors used to pose

for photos near Capone's mohair couch and chair, roll-top desk and bookshelves.

The popular tourist attraction eventually closed in 2008 and went into foreclosure. In October 2009, the mobster's old hideout eventually sold for $2.6 million to Chippewa Valley Bank. A five-minute sheriff's auction finalized the deal at the Sawyer County Courthouse.

Off the Tracks

Train wrecks were a fact of life in early Wisconsin. It wasn't uncommon for derailments or collisions with other trains to result in loss of life. Travelers took their lives in their hands when hopping aboard a passenger train during the days of steam.

Life on the road for circus folks was especially rough, tough and dangerous. A wreck involving the Campbell Brothers Great Consolidated Shows and a passenger train received national attention on August 11, 1910. Both trains were racing to be first to reach a junction near the Yellow River, not far from the village of Babcock. The circus train got there first but was rammed by the passenger train. Several cars of the circus train were demolished, resulting in death and injury to a number of exotic animals, which were buried alongside the tracks. Several elephants made their getaways in the confusion, and excited farmers helped corral the

frightened escapees. A marker memorializing the wreck can be found along State Highway 80/173, west of Pine Street in Babcock.

Several other notable circus train wrecks also occurred in Wisconsin. On July 7, 1892, several cars of the Cook & Whitby show were derailed in Richland Center. In another smashup, the Yankee Robinson Show train was wrecked at Merriland Junction on June 9, 1911. One sleeper was demolished and a second was heavily damaged.

Another major wreck occurred at Johnson's Creek on November 1, 1859, in which eight persons died after the train ran over an ox standing on the track. Morning editions of the state's newspapers trumpeted:

> *A terrible accident occurred this morning on the Chicago and Northwestern Railroad. A train, consisting of thirteen cars, filled with excursionists from Fond du Lac for Chicago, ran off the track at Johnson's creek, eight miles south of Watertown, Wisconsin.*
>
> *Eight persons are reported killed, and a number badly injured. The names of the killed, as far as known, are as follows: Mr. R.J. Thomas, N.S. Marshal, Mr. Boardman, and George F. Emerson. The following are reported as badly injured: A.B. Bonesteel, indian [sic] agent; l. Gillett; Judge Flint; Mrs. Radford; Van Buren Linead, all of Fond du Lac.*

Evening reports carried more grim news.

> *In addition to the killed by the railroad accident previously reported are Jerome Mason, telegraph operator; T.L. Gillett and J. Snow, of Fond du Lac; John Lund: C. Peterailla, and L. Sherwood, of Oshkosh; and Dr. T. Miner, of Watertown.*
>
> *Among the injured are E.H. Sykes, both legs cut off; Mrs. LEWIS, leg broken; Mrs. James Kinney, leg broken; and Mr. Baldwin, of Oshkosh, both legs broken.*
>
> *Van Buren Linead, reported among the wounded, has his skull fractured, and is not expected to recover. He is the editor of the* Fond Du Lac Press.

Another wreck occurred on September 21, 1910, due to a switch believed to have been thrown too soon. The error resulted in a train car derailment on the Green Bay & Western Railroad in which several passengers were injured. The *Stevens Point Gazette* reported on the accident in graphic detail:

> *The Green Bay & Western has for more than a quarter of a century been recognized as one of the safest roads in the state to travel upon, but passengers who went south on the branch from this city to Plover, last Saturday afternoon, were at least momentarily convinced that "all signs had changed." The train left here on time, at 2:30 and was entering on the "Y" north and west of*

Plover station. The brakeman had thrown the switch and then jumped on the forward end to throw another switch farther down.

The engine passed over as did also the forward truck of the combination passenger coach and express car, but before the rear trucks reached the switch it was thrown back. The mistake was not noticed soon enough to be rectified, and soon things commenced to present a dangerous aspect. The engineer stopped as quickly as possible, but not quick enough to prevent the rear trucks being torn loose and the overturning of the car, which fell upon its side.

Guy E. Morrill of this city, and Guy Pierce of Plover, were the only occupants of the express car at the time. The former sat upon a box, and as the car fell over he landed between the stove and wall on the opposite side to where he had been sitting, while the box landed just above his head, narrowly missing him. Fearing the stove would follow, Mr. Morrill quickly regained his feet and scrambled out upon the ground, but not until one of his shins had been cut and he was considerably bruised. Mr. Pierce saved himself by jumping from the side door, just as the car was tipping and had a narrow escape.

The coach was occupied by several passengers, among them being Mrs. Robt. Herman, Mrs. Wallace Verrill, Mrs. Cross, Mrs. John Lukaszvitch and two children, Mrs. H.A. Marlatt, Mrs. Jacob Suski and

Miss Rose Spring, all of the town Plover, Mrs. Chas. Glodowski of Arnott, Mr. and Mrs. Jos. Glodowski of this city, Mrs. U.J. Puariea of Buena Vista, A.C. Nelson of Scandinavia, and P. Leonhowdt of Sturgeon Bay, all of whom were cut and bruised.

Mrs. Herman, who is the wife of the section foreman at Plover, was the most badly hurt. A few weeks ago, while riding home on a hand car after attending a show in this city, she was accidentally thrown to the ground, breaking three ribs. On Saturday, she came here to consult a physician, and in the wreck the ribs were again torn apart and she was otherwise injured.

For several minutes, there was the wildest excitement among the occupants of the car, the ladies screaming and crying for help, but the train crew, assisted by P. Curran, the local agent here, who was temporarily in charge of the train, and Mr. Morrill set to work and soon had them out in safety. The car was quite badly wrecked, but was righted the next day and taken to Green Bay for repairs. General Superintendent. Frank B. Seymour arrived from Green Bay on the evening train and spent two or three days here looking after the wreck and settling up with those who were injured, visiting and interviewing several of them in company with Dr. G. Rood and Dr. von Neupert, Jr.

Working on a train crew was dangerous, as evidenced by a wreck on December 17, 1912, at Keil. Two trainmen were

killed, and the body of a third man was found mangled after the accident when a passenger train hit a freight train. Apparently, a signal had been obscured by snow.

Fireman Antone Schemick of Green Bay was killed outright and engineer Mathew Foley of Milwaukee died of his injuries when train No. 2 of the Chicago, Milwaukee & St. Paul Railway from the Upper Peninsula's Copper Country smashed into the other train. None of the passengers was seriously injured, although "a number were said to have been badly shaken up," according to newspaper reports.

Subsequent stories said that Schemick, the dead fireman, was married about a year prior to the wreck. Foley was described as a veteran in the service of the road. A third body, that of Albert Allard of Wayside, Wisconsin, was later found in the wreckage. The accident was caused by the engine of an extra freight train moving on a side track, where it did not clear the main track. Among those injured were P.F. Honey, mail clerk of Superior, Wisconsin, and Comet Bennette, a passenger from Santa, Wisconsin.

A Soo freight went through a bridge over the Black River west of Owen when the structure collapsed on May 24, 1912. A passenger train had crossed the trestle only an hour before. The *Fond Du Lac Daily Commonwealth* reported that the bridge "held up until the engine was safely across but gave way when the freight was about half over. Thirteen cars of merchandise were precipitated into the river. No

lives were lost." The newspaper related that "the bridge, which is a modern steel structure, was weakened by the high water. It will probably require several days to erect a new bridge and in the mean time all traffic will be detoured over the old Soo line through Ladysmith."

A wreck caused by careless switching on August 9, 1913, resulted in a riot in Superior, where 250 angry dockworkers went on strike when they learned that three laborers had died in the mishap. The *Stevens Point Journal* related the toll:

> *Nick Libest, laborer, Superior; John Koski, laborer, Superior; unidentified man, supposed laborer. The fatally injured: Isaac Isel, laborer, leg cut off; unidentified man, laborer, leg and arm cut off. Badly hurt; John Koshlo, bruised and cut by ore lumps; Charles Stanholm, laborer, bruised and cut; Reno Eskitine, laborer, bruised and crushed.*

According to the news accounts:

> *A moving train ran into a standing train, throwing the workmen into ore pockets and covering them with ore. Within a minute, several hundred workmen were on the scene, wildly digging into the pockets. All the ambulances in the city and a dozen doctors were summoned. The injured were removed to a hospital, which the dead were put in a switchhouse.*

Checking Out

The shooting death of Czech community leader Karel Jiran on March 19, 1921, shocked Wisconsin's ethnic community. Jiran, sixty-one, was secretary of the First Bohemian National Building and Loan Association in Milwaukee and was murdered by a farmer from northern Wisconsin, according to the *Milwaukee Sentinel*. The unnamed assailant apparently pushed his way into Jiran's office and killed the banker with a homemade shotgun. Patrons of an adjoining saloon chased the man, who was captured by police as he was running along the street with the crowd in hot pursuit.

The murderer had immigrated to the city from Bohemia in 1907 but moved north to farm. As reported in a front-page jailhouse interview, the elderly man claimed that Jiran had "constantly hounded" him and made him "a laughing-stock" after he upbraided the banker for not regularly attending a Czech drama club and not paying enough attention to preserving his heritage. According to the accused killer, Jiran forced him to move out of town by "constantly ridiculing me" whenever they came in public contact.

"It was then that I made a vow to have revenge," he told the *Sentinel* reporter. "That is the reason I made my own gun. Part of an old gun served as the barrel and a carved block of wood from my own trees was used as a stock."

The assailant's daughter, who lived in Milwaukee, had not seen her father for four years but said she had heard from other family members that he "had been cruel, suspecting of everyone in the house of trying to poison him." She said he would not eat "until some member of the family tasted food prepared for the table before he touched it."

Ten years earlier, a reporter for a Milwaukee Czech-language publication had written:

> *One of the best pupils of Llachek's School of Music, Karel Jiran, is leaving for Bohemia in order to complete his education in this art with the famous Prof. Sefcik. During the summer months, Prof. Sefcik's school is located at Pisek. In the beautiful, healthy, country atmosphere, his pupils benefit much more than in a stifling big town. The gifted young countryman goes on his journey to the source of perfect art with the best wishes for success from his parents, relatives, and acquaintances.*

Dad and Son Senators

Wisconsin senator Henry Dodge and Iowa senator Augustus Caesar Dodge were the first father and son to serve together in the United States Congress. The duo served from December 7, 1848, to February 22, 1855. Prior to that, the two had been delegates to the House of

Representatives from March 4, 1841, to March 3, 1845, before the Wisconsin and Iowa territories became states. Henry Dodge was also the first territorial governor of Wisconsin from 1836 to 1841 and again from 1845 to 1848. At that time, the region covered Wisconsin, Iowa and Minnesota.

ONE BUSY NORWEGIAN

After coming to America almost penniless in 1842, it seemed that James DeNoon Reymert never sat still. He sold his only coat for the price of a canalboat ticket and one dollar in cash to head to Wisconsin, following the lead of other Norwegian immigrants seeking land and a new life. It wasn't long before young Reymert made a name for himself in the Badger State. He launched his business career producing the state's first Norwegian-American newspaper, the *Nordllyste (Northern Light)*. Launched on July 29, 1847, the newspaper's original motto was "Freedom and Equality," but that was later changed to "Free Land, Free Speech, Free Labor, and Free Men."

In addition to his publishing ventures, Reymert was the first Norwegian to hold a state office in the United States; he was elected to the first state legislature in 1849. He was also elected a court justice, superintendent of schools and a county supervisor. As his reputation as an advocate for Scandinavian settlers in the Midwest, Reymert served as

vice-consul for Sweden and Norway to the United States and then was appointed receiver of the United States Land Office; named to the United States Subtreasury; was a district attorney; became a state elector; and held a variety of other public positions. A friend of Stephen A. Douglas, he became the Democratic nominee for Congress in his district on the 1860 Douglas ticket.

In order to secure his nomination in that campaign, Reymert and two friends paddled a birch-bark canoe one hundred miles down the Mississippi River from La Crosse to the Democratic state convention in Prairie du Chien. He then stumped two hundred more miles from Illinois to Lake Superior, making two or three speeches a day for six weeks, traveling each day at least twenty miles on horseback.

Remert also organized a life insurance firm, raised a Wisconsin regiment made up primarily of Norwegians in the Civil War and had an active law practice. For his health, Remert even lived for a few years in South America, homesteading in Peru. On July 27, 1875, he wrote about an attack by bandits:

> *I was living so exposed for want of reliable men about me that I could not say for how long I should hold my position. I have the land yet, all of it, but the Indians and vagabonds have stolen all my cattle and horses and burned my house. I held them back until they became too many for me as they counted 86 against myself and 5 of my Indians—6. However,*

that is not so bad as it might be, as we are all sound and safe and the cowardly vagabonds are some of them killed by this time.

Upon his return to the United States, he purchased several silver mines in the Arizona territory, naming them after places in which he lived. Among them were Milwaukee and Wisconsin. The peripatetic Reymert died in the spring of 1896 in Alhambra, California.

Trail of Tears

In the 1870s, Native Americans in Wisconsin were ordered out of the state by a federal mandate, but many refused to go to reservation lands in Nebraska. During the harsh winter of 1873 to 1874, the U.S. Army was needed to round up many Winnebagos, now commonly known as the Ho-Chunk Nation, who had continued to live on their tribal lands despite the government orders. Yet some of the tribe who were actually deported managed to slip back into Wisconsin.

Not all white Wisconsinites supported this practice, and many actively aided tribal members. Prominent Black River Falls entrepreneur Jacob Spaulding was among those lobbying for the Native American cause. He learned to respect his Winnebago neighbors through his surveying and real estate business, as a justice of peace, as

owner of a lumber company and gristmill and in running a general store

Initially, government agents, knowing of his influence with the Indians, offered Spaulding a large compensation package to induce them to leave the state. In reply, he snorted, "I am poor, and need money badly; but you never saw money enough to induce me to be false to my Indian friends." He argued that the Winnebagos were entitled to citizenship, as well as be to eighty-acre allotments. Gradually, his ideas took hold around his home community.

When the newspaper in nearby Sparta blasted Spaulding for defending the Winnebagos, Spaulding's local Black River Falls paper fired back its own salvo of words, saying that such criticism was "uncalled for upon a worthy citizen of Wisconsin." An editorial went on to read, "Uncle Jack [Spaulding] will continue to do all he can to make the Winnebagos citizens of the State in which they were born, and which they inhabited long before the editor of that paper emigrated to this region."

Spaulding and others persevered. In 1875, Congress agreed to let tribal members own between forty- and eighty-acre lots. Most plots were in scattered parcels in Jackson and Monroe Counties and over toward Wisconsin Rapids, where descendants of these first tribal settlers still live.

Hot Time in the Old Town Tonight

When Colonel William Cody's *Buffalo Bill's Wild West Show* thundered into Prairie du Chien on August 20, 1900, the locals were excited. Thousands of fans flocked into town from around western Wisconsin to watch sharpshooter Annie Oakley, see real buffalo and capture the flavor of the fading West. After the parade and matinee, the show folk went downtown for refreshing beverages, since it was a payday. However, a fight broke out in a tavern, resulting in a battle royal that tore up Prairie du Chien's main business district. The town marshal and several other persons were shot and wounded.

As the brawlers fought it out, the Wisconsin state militia was called up in Madison after Governor Edward Scofield was telegraphed that "the showmen were on a rampage, the police being powerless." But by the time the troops boarded a train to quell the riot, Cody had

ridden into the fray, blowing on a silver whistle to round up his men. He managed to get them all back to the show lot to stage a truncated evening performance before packing up and heading to Sparta, the next town on their route. The mêlée even made headlines in the faraway *New York Times*.

Bibliography

"American Dreams Festival." Immigrants Theatre Project. www.immigrantstheat.org/PLAYSdislocation2005.htm.

"Andrew Magnus Nelson." In *A Standard History of Portage County, Wisconsin*. Vol. II. N.p.: Lewis Publishing Co., 1919. [Courtesy of the Stevens Point Area Geneaology Society.]

"Babcock Roadside Memorial." HMdb.org. www.hmdb.org/marker.asp?marker=18287.

Baraboo News Republic. "Showman Supreme with the Felt Fedora." September 19, 2003.

"Barstow and the Balance." Wisconsin State Historical Society, Dictionary of Wisconsin History. www.wisconsinhistory.org/dictionary/index.asp?action=view.

Baxandall, Lee. "Furs, Logs and Human Lives: The Great Oshkosh Woodworkers Strike of 1898." *Green Mountain Quarterly* 3 (May 1976): 49.

"Beginning of the County's Criminal Record." Chap. 6 in *Richland County History, 1861–1906*. 1906. Available online at www.usgennet.org/usa/wi/county/richland/books/1906-6.htm.

Beloit Daily News. "Record Crowd Witnesses Big Martial Show: Many Veterans of World War Take Part in Sham Battle at Janesville." September 19, 1921.

Berger, Victor. "Real Social-Democracy." *Broadsides* (September 1906): 4.

———. Speech excerpt from 1912 National Socialist Convention Stenographic Report.

Bie, Michael. *It Happened in Wisconsin*. Guilford, CT: Globe Pequot/TwoDot Publishing, 2007.

"Birthplace of the American League." Milwaukee County Historical Society plaque.

Blaine, Senator. Statement on the Twenty-first Amendment. Seventy-sixth Congressional Record, 414, 1933.

BIBLIOGRAPHY

Blanchard, Louie. *Lumberjack Frontier: The Life of a Logger in the Early Days on the Chippeway*. Edited by Walker Wyman and Lee Prentice. Lincoln: University of Nebraska Press, 1969.

Blegen, Theodore C. *The Civil War Letters of Colonel Hans Christian Heg*. Northfield, MN: Northfield Publishing, 1936.

"A Booming Success for the Prairie Chicken in Wisconsin." Conservation Fund. www.conservationfund.org/.../prairie_chicken_habitat_conservation_wisconsin (accessed January 5, 2010).

Burns, Ken. "The Master Builder." *Vanity Fair* 459 (November 1998): 302–18.

Capital Times. "Declares Governor's Name Is 'Blain,' His Age 52, Not 50." May 7, 1925.

———. "Gov. Blaine Replies to Roethe on 'Blaine' and Age." May 11, 1925.

Centralia Enterprise and Tribune. "Albert Wheeler Fatally Hurt in a Runaway at Boscobel." September 14, 1895.

———. "Eddie Olson Found Near His Home with His Skull Crushed." September 14, 1895.

Child, Ebenezer. "Recollections of Wisconsin Since 1820." *Wisconsin Historical Collections* 4 (1859): 153–99.

"Circus World." Wisconsin Historical Society. http://circusworld.wisconsinhistory.org.

"Circus World Museum." Wikipedia. http://en.wikipedia.org/wiki/Circus_World_Museum.

City of Milwaukee. "History of the Milwaukee Police Department." Go Milwaukee. http://www.milwaukee.gov/Police/History779.htm.

Cleary, Catherine B. "Lavinia Goodell, First Woman Lawyer in Wisconsin." *Wisconsin Magazine of History* (Summer 1991).

Cropley, Carrie. "The Case of John McCaffary." *Wisconsin Magazine of History* 35, no. 4 (1951–52): 281–88.

Daily Commonwealth Fond Du Lac. "Soo Freight Goes Through a Bridge." May 24, 1912.

Davenport Daily Gazette. "The Governor of Wisconsin Drowned." April 23, 1862.

"Delavan History." Delavan Lake Area Chamber of Commerce. www.delavanwi.org/history.html.

"Delavan, Wisconsin." Wikipedia. http://en.wikipedia.org/wiki/Delavan_Wisconsin.

"Delavan, Wisconsin, Circus City." City of Delavan. http://ci.delavan.wi.us/history.cfm.

Dodgeville Chronicle. "Killer Captured." August 21, 1914.

Dorcey, Rose. "Wisconsin's First Airplane Crash." July 5, 2009. www.facebook.com/topic.php?uid=7419675949&topic=9030.

Drennan, William R., and Ron McRea. *Death in a Prairie House*. Madison: Terrace Press/University of Wisconsin Press, 2007.

Duke Law Journal (2000): 1619. Available online at www.law.duke.edu/shell/cite.pl?49+Duke+L.+J.+1619.

Duncan, Baird Douglas. "Constitutional Crossroads: Reconciling the Twenty-first Amendment and the Commerce Clause to Evaluate State Regulation of Interstate Commerce in Alcoholic Beverages, Cited: 49."

Durant, John, and Alice Durant. *Pictorial History of the American Circus*. New York: A.S. Barnes and Co., 1957. Fifth printing.

Eigel, John C. "Surviving Prohibition in Milwaukee." *Historical Messenger* 33, no. 4 (Winter 1977): 118–24.

Etter, Nicole Sweeney. "Fanciest Fielding First Baseman Ever." *Marquette Magazine* (Winter 2010): 24–27.

Fenimore Times. "John J. Blaine, Former U.S. Senator and Governor, Dies." April 18, 1934.

Fishel, Leslie H., Jr. "The Genesis of the First Wisconsin Civil Rights Act." *Wisconsin Magazine of History* 45, no. 4 (Summer 1966): 324–33.

"The Flagellants." Wisconsin Museum of Art. www.wisconsinart.org/Media/TheFlagellants/Default.aspx.

Foley, Ryan. "Survivor of Crash that killed Otis Redding Returns 40 Years Later." Associated Press Worldstream, November 30, 2007.

Fox, Charles Philip. *America's Great Circus Parade: Its Roots, Its Revival, Its Revelry*. Greendale, WI : Reiman Publishing, 1993.

Fox, Charles Philip, and Tom Parkinson. *The Circus in America*. Santa Monica, CA: Hennessey & Ingalls, 2002. Reprint.

Friedland, Roger, and Harold Zellman. *The Fellowship.* New York: Regan/HarperCollins, 2006.

Geenen, Paul. *Images of America: Milwaukee's Bronzeville, 1900–1950.* Charleston, SC: Arcadia Publishing, 2006.

Giles, Diane M., Beverly McCumber Brandl and Dane F. Pollei. *Focus on Louis Thiers: A Photographer's View of Kenosha.* Virginia Beach, VA: Donning Company Publishers, 1998.

Goc, Michael. *Forward in Flight, The History of Aviation in Wisconsin.* Friendship, WI: New Past Press, 1998.

"Grand Opera House, Oshkosh." Oshkosh Opera House Foundation. www.grandoperahouse.org.

Grand Rapids Tribune. "Babcock Circus Train Wreck." August 17, 1910.

Gregorich, Barbara. *Women at Play: The Story of Women in Baseball.* New York: Harcourt, Brace and Company, 1993.

Harper, Timothy. "No Pink Elephant at Nursing Home." Associated Press, August 30, 1977.

"Helping the Ancient Sturgeon." Great Lakes Science Center. www.glsc.usgs.gov/_files/factsheets/2000-4%20Sturgeon.pdf.

Hemman, Tom. "Alan Ameche Won Heisman Trophy as Wisconsin Badger, Had Impressive But Brief NFL Career." *Italian Times*, February 2010.

Hintz, Martin. *Afterglow: Our Farm Story*. Milwaukee, WI: Glenoble Publishing, 2010.

———. *Circus Workin's*. New York: Julian Messner, 1980.

———. *Got Murder? The Shocking Story of Wisconsin's Notorious Killers*. Madison, WI: Trails Books, 2007.

———. *Images of America: Irish Milwaukee*. Charleston, SC: Arcadia Publishing, 2003.

———. "International Irish Festival." *Irish American Post*, Spring 1999.

———. Richard Leonard interview, June 21, 2006.

———. "Spencer Tracy." In *Wisconsin Portraits*. Madison, WI: Trails Books, 2000.

———. *Tons of Fun*. New York: Julian Messner, 1982.

———. *Wisconsin Portraits*. Madison, WI: Trails Books, 2000.

———. *Wisconsin Sports Heroes*. Madison, WI: Trails Books, 2002.

Hintz, Martin, and Pam Percy. *Off the Beaten Path: Wisconsin*. Guilford, CT: Globe Pequot, 2008.

———. *Wisconsin Cheese: A Cookbook and Guide to the Cheese of Wisconsin*. Guilford, CT: Three Forks/Globe Pequot, 2008.

Historic Marker, 1958. "9XM-WHA: The Oldest Station in the Nation." Wisconsin State Historical Society, Dictionary of Wisconsin History. www.wisconsinhistory.org/dictionary/index.asp?action=view.

Hurder, Steven. "Edwin H. Cheney House." http://www.oprf.com/flw/Cheney.html.

Illasatel, Denni. "Student Leaving for Bohemia." *Bohemian*, May 21, 1911.

Indianapolis Sentinel. "A Big Blow." July 10, 1877.

Ingraham, Joanie, ed. *Centennial Memories: Celebrating the Village of Westfield, 1902–2002*. Ripon, WI: Ripon Community Press, 2002.

Inter Ocean. "Total Destruction of the Wisconsin State Institution for the Deaf and Dumb at Delavan." September 17, 1879.

Janesville Daily Gazette. "Circus Train Crash, Elephants Escape." August 18, 1910.

"John Heisman." Wikipedia. http://en.wikipedia.org/wiki/John_Heisman.

Jones, Meg. "100 Years of 'On, Wisconsin!'" *Milwaukee Journal Sentinel*, November 10, 2009.

———. "100 Years Ago, State Saw Its First Flight." *Milwaukee Journal Sentinel*, November 4, 2009.

Joseph, Frank. "The Monster of Rock Lake." In *The Lost Pyramids of Rock Lake*. Lakeville, MN: Galde Press, 2002.

Kaiser, Lisa. "Ezekiel Gillespie: Milwaukee's Champion of African-American Voting Rights." *Shepherd Express*, February 4, 2010.

Kasparek, Jon, Bobbie Malone and Erica Schock. "Automobile Culture." In *History of Wisconsin*, vols. 3 and 4. Madison: State Historical Society of Wisconsin, 2004.

Kaufman, Jennie. "Murder in Madison." *Ancestry Magazine*, March 23, 2007.

Kenosha Evening News. "Dedication of the Soldiers and Sailors Monument." May 30, 1900.

Kenosha Telegraph/Courier. "Kenosha's Grand Old Man." February 17, 1910.

Kingsley, R.S. "Wisconsin in the Defense Program." In *Wisconsin Blue Book*. Madison, WI, 1942.

"The Kissel Kar." Conceptcarz.com. www.conceptcarz.com/vehicle/z15191/Kissel-Kar-D-11.aspx.

Klement, Frank. "Brick Pomeroy: Copperhead and Curmudgeon." *Wisconsin Magazine of History* 35 (Winter 1955): 106–13, 156–57.

Kriehan, Ruth. *The Fisherfolk of Jones Island*. Milwaukee, WI: Milwaukee County Historical Society, 1988.

Kunz, Bruce. "Reader Remembers the Kissels." August 18, 2008. Available online at www.stltoday.com.

Lemberger, Mark. *Crime of Magnitude*. Madison, WI: Prairie Oak Press, 1993.

"Lone Rock, Wisconsin." http://www.tustison.com/hometown/history.shtml.

"Mamah Borthwick." Wikipedia. http://en.wikipedia.org/wiki/Mamah_Borthwick.

Marryat, Frederick. "An English Officer's Description of Wisconsin in 1837." *Wisconsin Historical Collections* 14 (1898): 137–53.

"Mathilde Franziska Giesler." Wisconsin Historical Society. www.wisconsinhistory.org/topics/shorthistory/19th.asp.

McBride, Sarah Davis. *History Just Ahead*. Madison: Wisconsin Historical Society, 1999.

McCann, Dennis. "3 Governors Held Office Within Weeks." *Milwaukee Journal Sentinel*, December 10, 1998.

Mesmer, Theodore. *The Welsh Hills of Waukesha County*. Wales, WI: Celtic Ink, 1997.

"Milkweed." Golden Harvest Organics. www.ghorganics.com/page8.html.

Miller, Mike. "Pilot Honored 50 Years After Death in Lake Monona." *Capital Times*, May 8, 2008.

———. "State's Circus Hero Dies." September 13, 2003.

Milwaukee Journal. "Negro Axman Gives Self Up." August 16, 1914.

———. "Notorious Murderer Ed Gein Dies at 77." July 26, 1984.

———. "Rundown Farm House Was Murder Factory." November 8, 1957.

———. "Scene of Explosion Charnel House." November 25, 1917.

———. "Twelve Detained in Bomb Case." November 27, 1917.

Milwaukee Journal-Sentinel. "Concerts Dedicated to 3 Singers Who Died in Plane Crash." January 21, 2009.

Milwaukee Sentinel. "Body of Deckert Is Blown to Bits." November 25, 1917.

———. "Bohemian Leader Slain, Aged Assassin Trapped Near Murder Scene." March 19, 1921.

———. "Care Home 'Crashed' by Elephant." August 29, 1977.

———. "Cheney Turns from Body of Former Wife." August 17, 1914.

———. "Detective's Watch Blown From Pocket." November 25, 1917.

———. "The Wedding Ring Blown From the Finger." November 25, 1917.

———. "Woman Store Owner Dead; Suspect Held." November 17, 1957.

Minnich, Jerry, ed. *The Wisconsin Almanac*. Madison, WI: North Country Press, 1989.

Muldoon, Paul. "Shining Brow." Complete Review. www.complete-review.com/reviews/muldoonp/shiningb.htm.

National Transportation Safety Board. "NTSB Identification: CHI90MA244." NTSB Aviation Accident Database. http://www.ntsb.gov/NTSB/brief.asp?ev_id=20001212X23968&key=1 (accessed July 7, 2009).

New York Times. "An Awful Hotel Disaster, Nearly One Hundred Lives Lost at a Fire in Milwaukee." January 11, 1883.

———. "Lynch Law in Wisconsin: The West Bend Case—Interesting Particulars." August 8, 1855.

———. "Wild West Show Creates Panic." August 21, 1900.

North, Henry Ringling, and Alden Hatch. *The Circus Kings: Our Ringling Family Story.* N.p.: University of Florida Press, 1960. Reprint, 2008.

Oliver, John William. "Historical Fragments: Draft Riots in Wisconsin During the Civil War." *Wisconsin Magazine Of History* 2 , no. 3 (1918–19): 335–38.

Oshkosh Daily Northwestern. "Two Trainmen Killed." December 17, 1912.

Ozanne, Robert W. *The Labor Movement in Wisconsin.* Madison: University of Wisconsin Press, 1984.

"Pabst Theater." Pabst Theater Foundation. www.pabsttheater.org.

Paradis, Trudy Knauss, and E.J. Brumder. "German Painters." In *German Milwaukee: Its History-Its Recipes, a Tribute to Milwaukee's German Heritage.* St. Louis: G. Bradley Publishing, 2006.

Paul, Barbara, and Justus Paul, eds. *The Badger State: A Documentary History of Wisconsin*. Grand Rapids, MI: Wm. B. Eerdmans Publishing Co., 1979.

Peck, George W., ed. *Wisconsin: Comprising Sketches of Counties, Towns, Events, Institutions, and Persons, Arranged in Cyclopedic Form*. Madison, WI: Western Historical Association, 1906.

Pendleton, Alexander T., and Blaine R. Renfert. "A Brief History of Wisconsin's Death Penalty." *Wisconsin Lawyer*, August 1993.

Philadelphia Inquirer. "Deaf and Dumb Institute Burns." September 17, 1879.

Philadelphia Press. "Railroad Accident, Eight Killed." November 2, 1859.

Pixley, R.B. *Wisconsin in the World War*. Milwaukee: Wisconsin War History Co., 1919.

Rankin, George William. *William Dempster Hoard*. Fort Atkinson, WI: W.D. Hoard and Sons, Co., 1925.

Reymert, Martin L. "James Denoon Reymert and the Norwegian Press." www.naha.stolaf.edu/pubs/nas/volume12/vol12_4.htm.

Richland Center Rustic. "Tornado Smashes Lone Rock." 1918.

Rolling Stone. "100 Greatest Guitarists of All Time." http://www.rollingstone.com/news/story/5937559/the_100_greatest_guitarists_of_all_time.

Roosevelt, Theodore. Milwaukee campaign speech, October 14, 1912. Available online at www.theodoreroosevelt.org/.../speech%20kill%20moose.htm.

Rosholt, Malcolm. *The Wisconsin Logging Book, 1839–1939.* Rosholt, WI: Rosholt House, 1980.

Schechter, Harold. *Deviant: The Shocking True Story of Ed Gein.* New York: Pocket Books, 1989.

Secrest, Meryle. *Frank Lloyd Wright.* New York: Alfred A. Knopf, 1992.

Shepler, John. "Golden Age of the Circus: The Era of Barnum & Bailey and the Ringling Brothers, 1999–2009." http://www.JohnShepler.com.

"Shining Brow." http://www.daronhagen.com/brow.

"Signs of Summer: Monarchs and Milkweed." Wisconsin Department of Agriculture. www.dnr.state.wi.us/org/caer/ce/eek/veg/.../milkweed.htm.

Smith, A. Morton. "Circus Railroad Wrecks." *Hobbies* (November 1945): 22–23.

Spargo, John, ed. Amendment to Article 2, Section 6, proposed by William Lincoln Garver of Missouri. National Convention of the Socialist Party, Indianapolis, May 12–18, 1912.

"Spencer Tracy." Milwaukee Irish Fest. www.irishfest.com/archives/exhibits/hall-of.../tracy-spencer.php.

"Spencer Tracy, Biography." IMDB. www.imdb.com/name/nm0000075/bio.

State of Wisconsin Supreme Court. *Peter Bianchi et. al. v. State*.169 Wis. 75., October Term, 1918, No. 10, and January Term, 1919, March 7–April 2, 1919.

Stevens Point Daily Journal. "Circus Train Wrecked." August 20, 1910.

———. "Dangerous Heroism." November 20, 1909.

———. "Endeavor, Wisconsin, Fire." November 20, 1909.

———. "Superior Wisconsin Train Wreck." August 9, 1913.

Stevens Point Gazette. "Trainmen Die in Crash." December 17, 1912.

Stone, Irving. *Clarence Darrow.* New York: Signet Books, 1971.

Tanzilo, Bobby. "Wilde Didn't Impress Milwaukee Much." www.onmilwaukee.com.

Theobald, Mark. "C.T. Silver Motor Company." www.coachbuilt.com/bui/s/silver/silver.htm.

"This Day in History 1912: Theodore Roosevelt shot in Milwaukee." www.history.com.

"Travel to Mackinac." Mackinac State Historic Parks. www.mackinacparks.com/Userfiles/File/Travels_to_Mackinac.pdf.

"2004 O'Neill Playwrights and Musical Theater Conference." Eugene O'Neill Theater Center. www.oneilltheatercenter.org/news/072304.htm.

Tyler, Troy. "Ghosts of the Prairie: Haunted Wisconsin, Grand Opera House, Oshkosh." www.prairieghosts.com/oshkosh.html.

Bibliography

United States Geological Survey. "1947 Wisconsin Earthquake." Wisconsin Earthquake History. January 30, 2009.

USA Today. "Chicago Mobster Al Capone's Hideout for Sale." September 19, 2009.

Van Matre, John. "Circus Events: Yankee Robinson Train Wreck." *Circus Historical Society Bandwagon* 3, no. 2 (April 1944): 6–7.

"Victor Berger." Wisconsin Historical Society. www.wisconsinhistory.org/topics/vberger.

Von Hake, Carl A. "Wisconsin Earthquake History." *Earthquake Information Bulletin* 10, no. 3 (May–June 1978).

Weekly Home News. "Murderer of Seven: Sets Fire to Country Home of Frank Lloyd Wright Near Spring Green." August 20, 1914.

Weinberg, Arthur, ed. *Attorney for the Damned: Clarence Darrow in the Courtroom.* Chicago: University of Chicago Press, 1989.

Wells, Robert. *This Is Kilbourntown.* Milwaukee, WI: Time Holdings, Inc., 1971.

Bibliography

———. *Yesterday's Milwaukee*. Miami, FL: E.A. Seamann Publishing Co., 1976.

"When Wisconsin Had Two Governors." Wisconsin Historical Society. www.wisconsinhistory.org/odd/archives/001972.asp.

Wilson, Mary. *The History of Lake Mills*. Madison, WI: Omnipress, 1983.

"Wisconsin Earthquake History." USGS. http://earthquake.usgs.gov/regional/states/wisconsin/history.php.

Wisconsin Historical Society. "Civil War Draft Riots (1862)." Turning Points in Wisconsin History. www.wisconsinhistory.org/turningpoints.

———. "Henry Dodge." Turning Points in Wisconsin History. www.wisconsinhistory.org/turningpoints/search.asp?id=643.

"Wisconsin's Prairie Chickens, History." University of Wisconsin-Stevens Point. www.uwsp.edu/wildlife/pchicken/index.aspx.

Wisconsin State Journal. "Insane Negro Kills Five in Frank Lloyd Wright's 'Love Bungalow.'" August 16, 1914.

———. "Roethe Wrong, Blaine Says in Statement of Real Facts." May 12, 1925.

Wisconsin State Journal/Capital Times, comp. "Aviation Accidents, Dane County." November 12, 2009.

Wisconsin State Supreme Court. Application of Miss Goodell, 48 Wis. 693, 1879.

———. *John F. Jelke Company v. Emery*. 193 Wis. 311, 1927.
Wisconsin Statutes. Ch. 279, sec. 352-365, Laws of 1925.

———. Motion to admit Miss Lavinia Goodell to the Bar of this Court, 39 Wis. 232, 1875.

"Wisconsin Timeline." SHG Resources. www.shgresources.com/wi/timeline.

Woodall, Bernie. "Timeline: Kenosha, Wisconsin, in Auto History." *Reuters*, October 11, 2009.

Wright, Frank Lloyd. *An Autobiography*. Frank Lloyd Wright Foundation. http://www.pbs.org/flw/buildings/taliesin/taliesin_wright04.html.

———. "Frank Lloyd Wright Issues a Statement to His Neighbors." *Wisconsin State Journal*, August 21, 1914.

Wyman, Mark. *The Wisconsin Frontier*. Bloomington: Indiana University Press, 1998.

Zeitlin, Richard H. *Germans in Wisconsin*. Madison, WI: State Historical Society, 2000.

———. *Wisconsin and the Civil War*. Madison, WI: State Historical Society, 1998.

"Ziggy, an Elephant with Issues." Roadside America. www.roadsideamerica.com/pet/ziggy.html.

"Ziggy (Ziegfeld)." Wikipedia. http://en.wikipedia.org/wiki/Ziggy_(elephant).

About the Author

Martin Hintz has written about one hundred books for various publishers, including *Celebrate the Legend: 25 Years of Milwaukee Irish Fest* (Milwaukee Irish Fest, 2005*)*; *Got Murder? The Shocking Story of Wisconsin's Notorious Killers* (Trails Publishing, 2007); *Wisconsin Cheese: A Cookbook and Guide to the Cheeses of Wisconsin* (Globe Pequot, 2008); and *Off the Beaten Path: Wisconsin* (Globe Pequot Press, 2008; nine editions).

He has published articles in major newspapers and consumer and trade periodicals, including the *Chicago Tribune*, the *New York Post*, the *Chicago Sun-Times*, *National Geographic World*, *Irish Music Magazine*, *Where to Retire Magazine*, *American Heritage*, *Interval*, *American Archaeology*, the *St. Petersburg Times*, the *Wisconsin Academy Review*, *Billboard*, *Amusement Business*, *Midwest Express Magazine*, *Belfast News*, *City Lifestyle*, *Northshore Lifestyle*, *Dodge Van Magazine*, *Jewish Heartland*, *Travel Holiday*, *Corporate Report*

About the Author

Wisconsin, *GolfWeek*, *Milwaukee Magazine*, *Shepherd Express*, the *Daily Herald*, the *Jewish Chronicle*, the *Writer*, *Midwest Living*, *MotorHome*, *Meetings California*, *Dig*, *Michigan Living*, *Home & Away*, *M Magazine*, the *Group Travel Leader*, *Bus Tour Magazine* and numerous others.

Visit us at
www.historypress.net